IMAGES
of America

SOUTH BOSTON

IMAGES
of America

SOUTH BOSTON

Anthony Mitchell Sammarco

ARCADIA

First printed in 1996.
Reprinted in 1998, 1999, 2000, 2001.

Published by Arcadia Publishing,
an imprint of Tempus Publishing, Inc.
2A Cumberland Street
Charleston, SC 29401

Printed in Great Britain.

For all general information contact Arcadia Publishing at:
Telephone 843-853-2070
Fax 843-853-0044
E-Mail sales@arcadiapublishing.com

For customer service and orders:
Toll-Free 1-888-313-2665

Visit us on the internet at http://www.arcadiapublishing.com

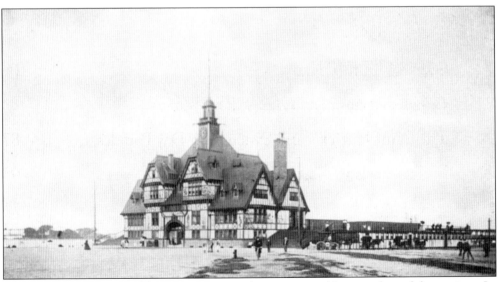

The Head House was an elaborate structure with numerous gables, panels, and decorations. Its view of Boston Harbor from Marine Park was unsurpassed.

Contents

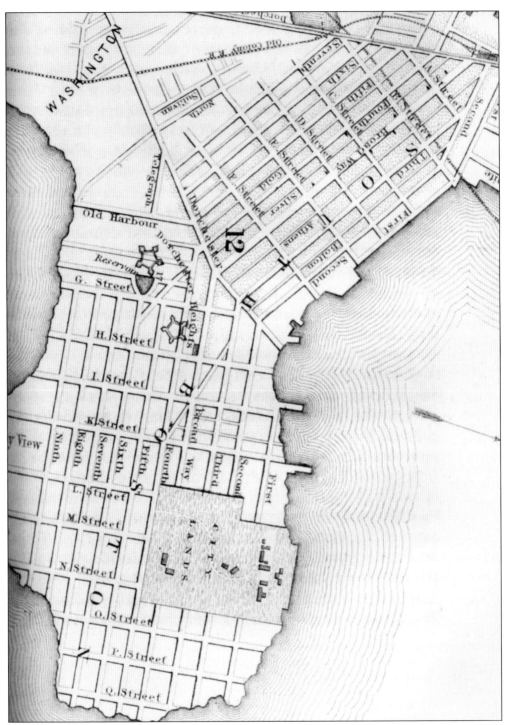

South Boston, originally known as Dorchester Neck or Great Neck, was laid out between 1804 and 1809 by Mather Withington and Stephen Badlam, surveyors from Dorchester. With a grid-plan, the new streets radiated from Dorchester Street and created an urban neighborhood from the once pastoral farmland.

Introduction

The Early History and Development of South Boston

"Dorchester was chosen by the early settlers on account of the abundant pasturage Great Neck [South Boston] afforded their cattle," says William Dana Orcutt, in *Good Old Dorchester* (1908). The Puritans settled Dorchester in 1630, at what we know as Edward Everett Square, or Five Corners as they called it. For the next two centuries Dorchester was comprised of farms and elegant country seats, with a productive mill complex along the Neponset River at the Lower Mills.

Dorchester Street, leading to Broadway, represents the original cow path to the pasture lands; a wooden gate was extended across the path at the present junction of Dorchester Avenue and Dorchester Street to contain the pasturing cows. For the first decade after the settlement, Great Neck was used for pasture, with relatively few inhabitants on the peninsula. By the time of the Revolution, Great Neck was inhabited by twelve families, a growth almost triple that of the previous century's population. The Neck was the scene of tremendous revolutionary activity, with Dorchester Heights being fortified by the American troops as a stronghold commanding Boston Harbor.

Led by General Washington, the fortifications were built by an estimated three thousand men in such a manner as to dispel General Howe and his officers. The British troops and Loyalists in Boston summarily set sail for Halifax, Nova Scotia, on March 17, 1776. Following this feverish excitement in fortifying the Heights, the Neck again resumed its placid existence as a farming community until the last decade of the eighteenth century.

Inhabitants of Great Neck attended the Meeting House in Dorchester, and their children attended the school located on the northwest slope of Meeting House Hill. However, due to flooding conditions on the causeway at Washington Village (now Andrew Square), inhabitants could not attend either church or school at various times during the year. To allow for the education of their children, the inhabitants of Great Neck supported a school which was subsidized in part by a contribution from the Dorchester Selectmen. These unsatisfactory conditions, unresolved by the town, led to discontent and eventual action.

In 1803, a number of the Mount Vernon Proprietors, who laid out and developed Beacon Hill, purchased large tracts of land on the Neck for speculative purposes. Bostonians including William Tudor, William Gardiner, William Greene, Jonathan Mason, and Harrison Gray Otis presented a petition to Boston in 1804 to annex the Neck. "It was thought that Boston could not accomodate many more inhabitants, and that Dorchester Neck was the most accessible to it, and could easily be united by a bridge." The Town of Boston immediately formed a

committee, which reported on January 17, 1804, that "the Town will consent that the lands on Dorchester Neck, agreeably to the Petition of the Owners, shall be annexed to and incorporated with the Town of Boston, provided it can be done on such conditions as the Town shall hereafter agree to."

Subsequently, additional meetings were held, but the fervor and excitement concerning annexation was so great that little business was transacted. The petitioners' positions were clearly evident, for "in the mean time the petitioners were making the most strenuous efforts to effect the passage of the bill. They had bought a large number of acres at Mattapanock [Dorchester Neck] at a very cheap rate, and they were convinced that if the bill should pass, the property would immediately rise in value. It was also considered highly important to the Town of Boston that the Neck should be annexed, as it was then supposed the penninsula [Boston] itself could not contain many more inhabitants."

The Town of Dorchester vehemently opposed the annexation of Great Neck to Boston. An Anti-Annexation Committee was formed on January 23, 1804, with Moses Everett being chosen as moderator. The committee consisted of nine persons: Ebenezer Wales, Stephen Badlam, John Howe, Samuel Withington, and Major James Robinson, with Ebenezer Tolman, Lemuel Crane, Thomas Mosely, and Edward Baxter representing the selectmen of Dorchester. This committee was formulated to ensure Dorchester's rights in the annexation procedures, and a remonstrance was presented to the General Court of Massachusetts in 1804.

The cumulation was on March 6, 1804, when Dorchester Neck was annexed to Boston without compensation to Dorchester for the land. Land speculators realized tremendous profits, and the twelve families that inhabited Great Neck attained great wealth through the rise in land values. "Thus, when the bill passed . . . those who had held out not only had to give up the land, but also lost the money which they might have received."

Boston immediately constructed a bridge connecting South Boston, as the Neck was renamed after the annexation, to Boston proper. This bridge was built from South Street in Boston to the Neck at South Boston, with an annual assessment to the petitioners of the annexation. "In spite of this, it was completed [in 1805] at an expense of $56,000.00. It was afterwards known as the South Bridge."

Changes were soon rampant on the Neck, as William Tudor built a row of houses along Broadway at A Street, known as the Brinley Block. His profit through land speculation led to further development of the former pasture land as an urban settlement. One Mr. Murphy constructed the South Boston Hotel, known by the large golden ball outside his public house. The changes were swift, and tremendous urban growth occurred in South Boston after 1804, when the street-grid plan by Stephen Badlam and Mather Withington, two well-known land surveyors, was laid out. With streets being listed from "A" at Broadway Station, it rose in letters to "P" Street at City Point; cross streets, which ran east to west, were named "First" Street on up. The minor streets were named after some of the land speculators; this is why Tudor, and other streets, were laid out by name rather then by letter or number.

The growth realized within the first decades after the annexation was low in comparison to the building boom South Boston was to experience from the Civil War to World War I. But despite the tremendous increase in its population, South Boston has retained a definite sense of community. In this photographic history, the pride in this community, "Southie Pride," comes forth clear and strong. As the first area annexed by Boston in the nineteenth century, South Boston set the pace for the other towns annexed after it: Roxbury, Dorchester, Charlestown, Brighton, West Roxbury, and Hyde Park.

One
Along
Dorchester Avenue

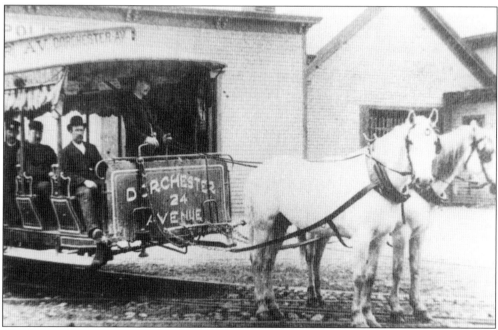

The horse-drawn streetcars that served South Boston ran along Dorchester Avenue from Boston. The horses would pull the streetcars along rails; passengers were shaded by canvas awnings in the summer and warmed by straw-strewn floors in the winter.

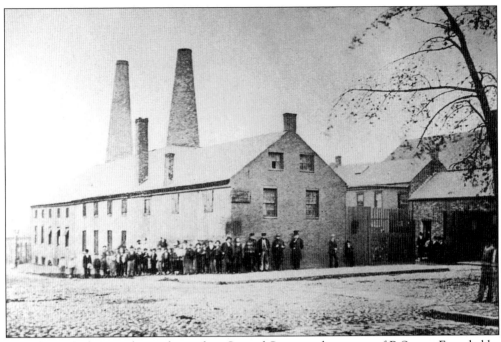

The Phoenix Glass Works was located on Second Street at the corner of B Street. Founded by Thomas Cains, blown flint glass was produced in the early nineteenth century by these workers, who are shown here posing in front of the glass factory.

Thomas Cains, an Englishman, settled in South Boston and produced a flint glass that was compared in quality to that of the Boston and Sandwich and the New England Glass Companies. A prosperous manufacturer, he was a leading citizen of South Boston.

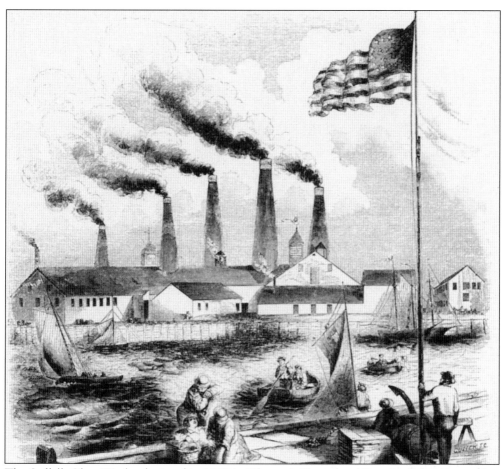

The Suffolk Glass Works, depicted in 1849 in Gleason's *Pictoral and Drawing Room Companion*, was one of four glass manufacturers in South Boston; the other three were the Phoenix, the South Boston, and the American Flint Glass Works. The skilled work force, which included glass blowers and molders to produce the flint glass, settled largely in the area west of D Street.

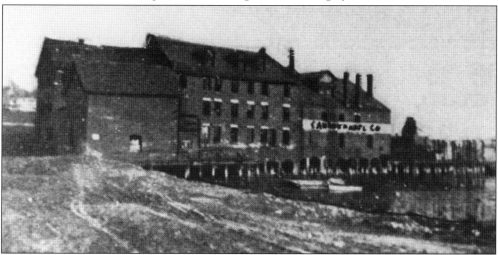

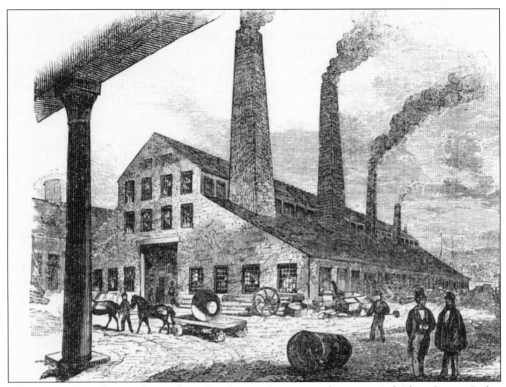

Alger's Iron Foundry was located on Dorchester Avenue at the corner of Alger Street. In his iron foundry, Cyrus Alger and his workers not only cast 25,000 one-pound cannons, but they supplied the United States with cannonballs during the War of 1812.

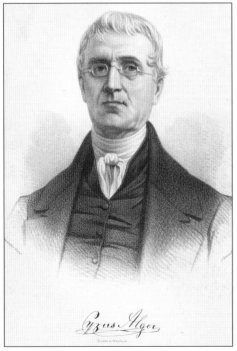

Cyrus Alger opened his foundry in South Boston in 1809. Through experimentation, he was able to purify cast iron so as to give it more than triple the strength of ordinary cast iron, and thereby sidestep his competitors.

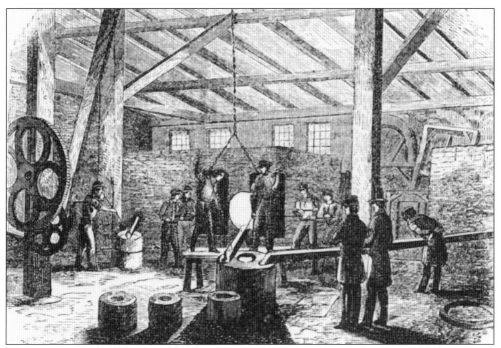

The interior of Alger's Iron Foundry had fairly primitive conditions for the production of cast iron. With open vats of molten iron, and the intense heat necessary for the operation, the foundry was as dangerous as it was profitable.

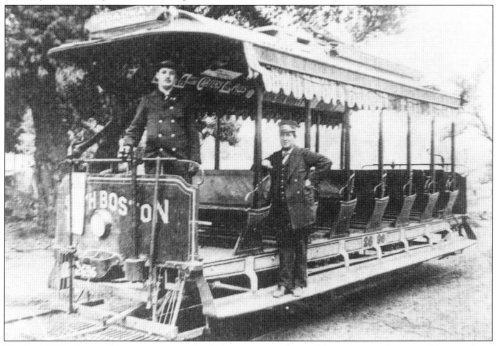

By the 1880s, horse-drawn streetcars had given way to those driven by conductors. The mode of locomotion changed, but as can be seen here, canvas awnings still shaded passengers from the sun during the summer.

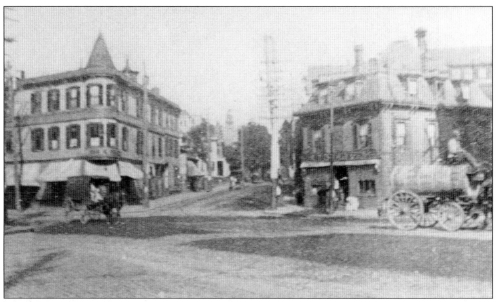

Andrew Square is the junction of Dorchester Avenue and Dorchester, Southampton, and Preble Streets. Named for Governor John Albion Andrew, the area was originally known as Washington Village and was annexed to Boston from Dorchester in 1855. The horse-drawn cart on the far right would "water," by a sprinkling system, the streets at the turn of the century to keep the dust down.

Preble Street, which connects Dorchester Avenue to Old Colony Avenue, was named for William Henry Preble, a lawyer in Boston and an active member of the community.

14

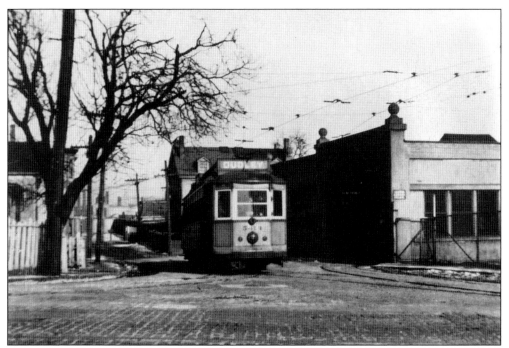

Streetcars, and later buses, connected the Andrew Square Station on the "Red Line" of the MBTA with points throughout South Boston, Dorchester, and Roxbury. This streetcar is leaving from the rear of Andrew Square Station and is headed east toward City Point.

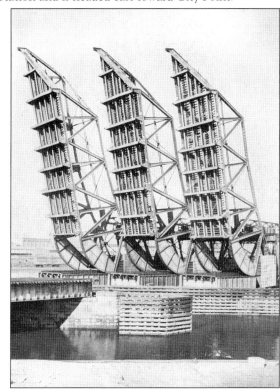

The Three Tower Bridges cross the Fort Point Channel, connecting the New York, New Haven and Hartford Railroad with the Boston terminal. This six-track rolling lift bridge indicates the large number of railroad lines that passed through South Boston to the main terminus at South Station.

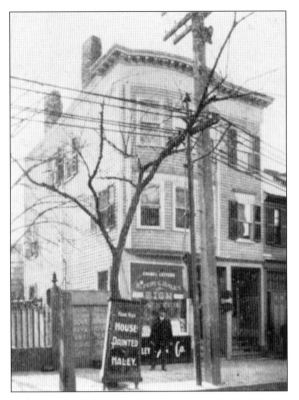

This three-decker was built on West Broadway next to the Saints Peter and Paul Church. Originally the shop of Albert C. Haley, a noted painter and decorator in South Boston, it had apartments on the second and third floors. Today, it has been remodeled as law offices.

Damrell Street, which connects Dorchester Avenue to Old Colony Avenue, was named for Charles Stanhope Damrell, a former clerk of the Building Department of the City of Boston.

Two
West Broadway

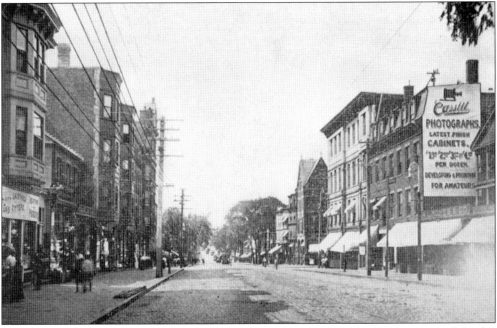

West Broadway, looking west from F Street, was built up by the turn of the century with banks, stores, commercial concerns, and apartment buildings. On the right is E Street and Cassill's Cabinet Photograph Studio. (Photograph courtesy of the South Boston Historical Society, hereinafter referred to as SBHS.)

Along West Broadway, between Broadway Station and A Street, were brick townhouses that were built between 1810 and 1825. Known as the Brinley Block, they faced the present Saints Peter and Paul Church. These townhouses were built as speculation by William Tudor, a member of the Mount Vernon Proprietors, who had pushed for Dorchester Neck to be annexed to Boston.

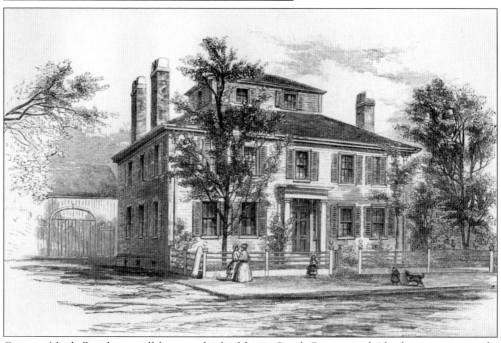

Captain Noah Brooks, a well-known shipbuilder in South Boston and "the best specimen of a true Yankee" according to the Honorable Abbott Lawrence, built his house on West Broadway between E and Dorchester Streets. A Federal mansion with a monitor roof, it overlooked Brooks' shipyard at Leek's Hill, the area just east of the property.

The Little House, a settlement house established at the turn of the century, was located at 73 A Street, at the corner of Athens Street. Built c. 1820, this house was typical of the wood-framed houses being built in the first two decades after South Boston was annexed to Boston.

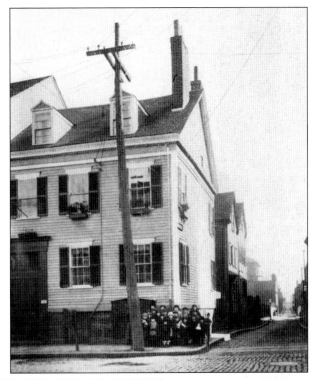

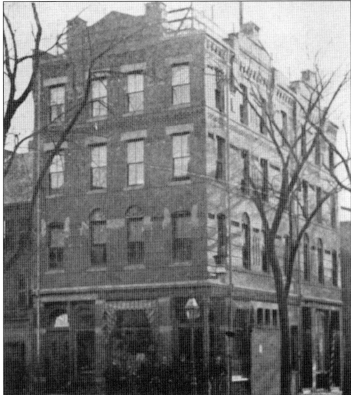

The Grover Block was at the corner of B and Fourth Streets, and was built by Elbridge H. Grover in 1880. Grover operated an apothecary shop on the first floor; the upper floors were apartments.

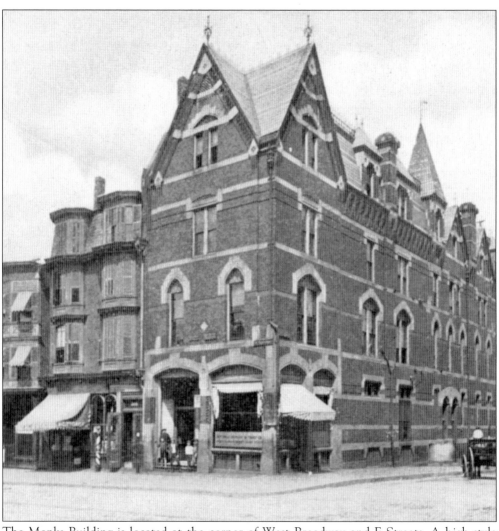

The Monks Building is located at the corner of West Broadway and E Streets. A high-style Gothic Revival brick structure, it was the office of the Mattapan Deposit and Trust Company, which by its charter was "authorized not only to receive deposits subject to check and transact a general banking business, but to act as trustee of estates and trust funds."

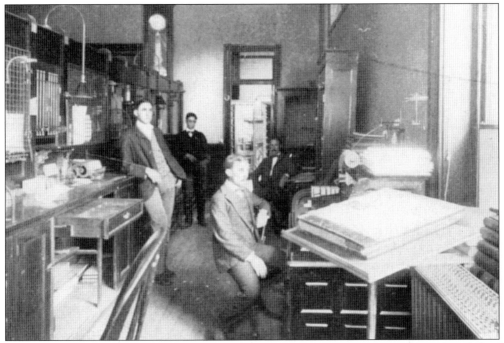

This photograph of the office of the Mattapan Deposit and Trust Company shows, from left to right: W.S. Fretch, assistant actuary; George A. Tyler, actuary; and seated, Richard J. Monks, president. In the rear is an unidentified teller.

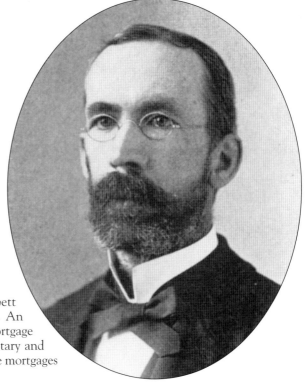

The real estate office of P.B. Corbett was located at 321 West Broadway. An auctioneer, insurance, and mortgage broker, Corbett was also a public notary and offered "money to loan" on real estate mortgages to those in need.

Carew's Confectionery Store was operated by Charles H. Carew on West Broadway at the corner of Dorchester Street. The store, converted from *c.* 1840 houses, was a popular place where "the best grades of confectionery were to be found" in South Boston.

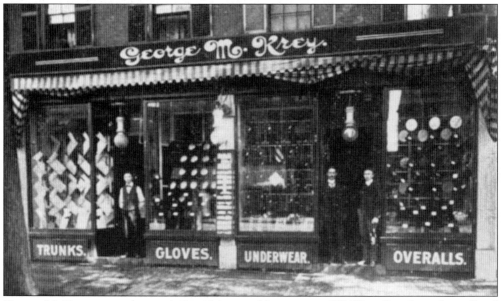

George M. Krey operated a men's furnishings and hat store at 158 West Broadway that offered trunks, gloves, underwear, and overalls in addition to a full line of goods. Standing in the doorway is Mr. Krey (to the left), with two of his shop assistants.

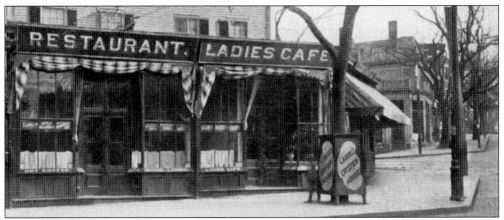

Charles H. Carew's confectionery shop became so successful that he later expanded his business to include a restaurant and a ladies cafe. The expanded business was adjacent to the candy store at the corner of Dorchester Street.

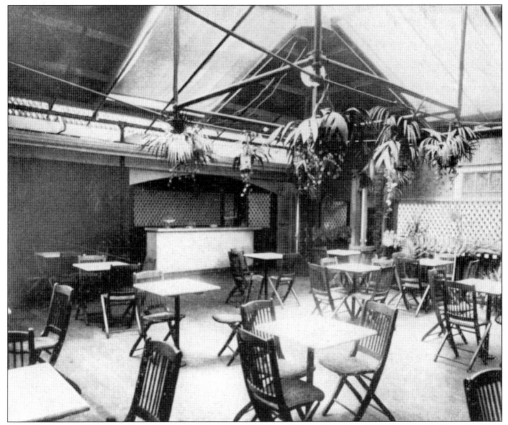

The Summer Palm Garden was a "tropical paradise" where patrons of Carew's could enjoy their ice cream in a suitable environment. The space was known as "Carew Hall" and could be rented for parties and entertainments during the winter.

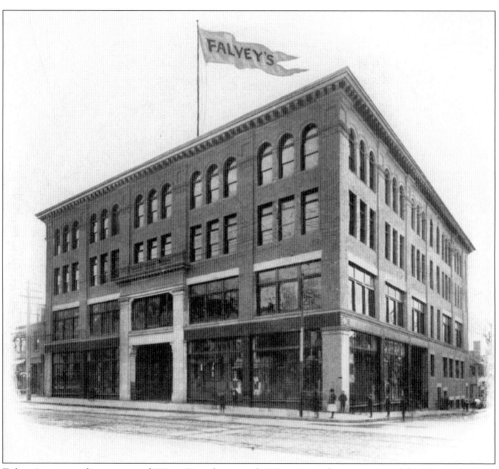

Falvey's was at the corner of West Broadway and F Street, and was operated by J.F. and W.H. Falvey. Built in 1900, the building was praised for its use of "Indiana limestone and cream pressed brick." F.W. Woolworth's was located on the first floor for many years, and the site is now a CVS drugstore.

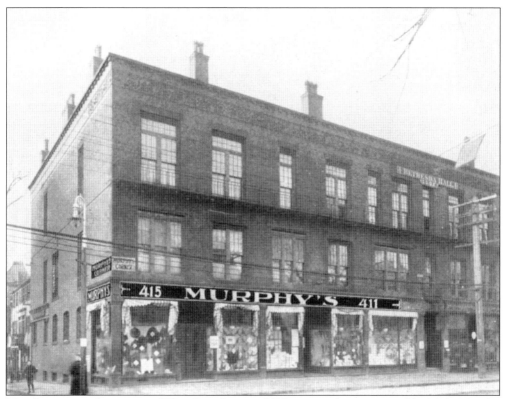

Murphy's was at the corner of West Broadway and F Street, and was operated by M.A. Murphy and her brothers, William and James Murphy. A department store in every sense of the word, Murphy's was said to have thirty departments where one could purchase anything from ostrich feather hats to needles and thread. Today, this handsome building has stores on the first floor and rental space above.

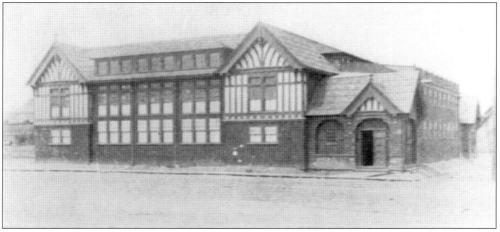

The D Street Gymnasium was built between West Fourth and West Sixth Streets as a place for neighborhood children to learn calisthenics. Gymnasiums were only introduced to this country in the late nineteenth century, and this impressive post-and-timber-framed building was a well-used community building until it was demolished to make way for the D Street Housing Project.

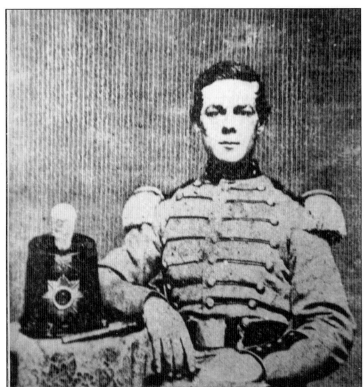

William G. Bird was a member of the Pulaski Guard, a cadet group in South Boston in the mid-nineteenth century. Local militias drilled in distinctive uniforms and snappy hats that were proudly shown off during maneuvers.

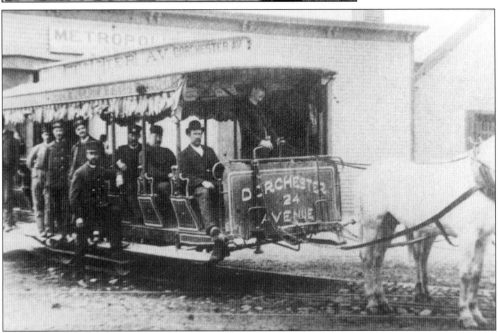

As South Boston's population began to increase steadily after the Civil War, public transportation began to be handled by "street railway" associations. The Dorchester Avenue Line (No. 24) was operated by the Metropolitan Street Railway Association. Conductors and company officials pose here in the streetcar outside the car barns.

Three
Perkins Square and East Broadway

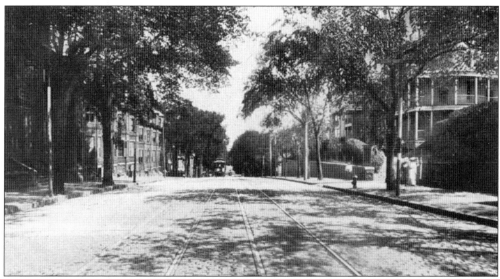

East Broadway, looking east from G Street, was more residential than West Broadway. The crest of the hill was known locally as "Pill Hill" because a large number of physicians had homes in the neighborhood. On the right can be seen the Perkins Institution for the Blind, and on the left is a row of townhouses built in the 1870s. Note the streetcar approaching from Flood Square. (Courtesy SBHS.)

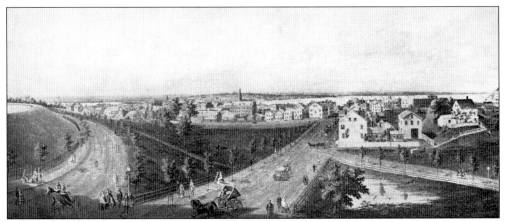

South Boston, in this romantic view from 1850, was fast becoming a neighborhood that attracted a wide range of people. On the right is the Perkins Institution for the Blind and a group of houses near Bird Lane. On the left is the reservoir built on Dorchester Heights that provided South Boston, and parts of Boston, with fresh drinking water. The street curving around the reservoir would later be laid out as Thomas Park. (Courtesy SBHS.)

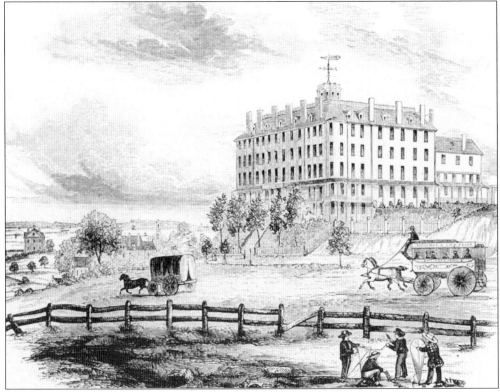

In 1838 the Perkins Institution for the Blind moved from Boston into the Mount Washington Hotel, which had failed after only one year of business. The large hotel, which had panoramic views of Boston Harbor and more than ample room for pupils, was remodeled by Dr. Howe and became an important part of South Boston. A horse-drawn omnibus, labeled "Broadway and City Point," served as the principal means of transportation to Boston in the mid-nineteenth century.

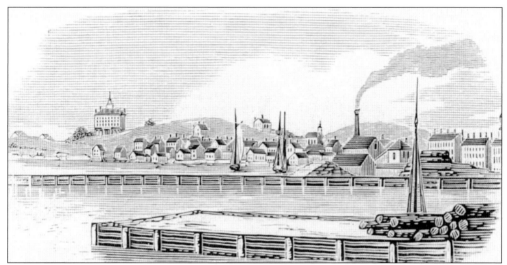

By 1839, when John Warner Barber made this sketch for his book *Historical Collections of Massachusetts*, South Boston had already been a part of Boston for three decades and was a thriving community, with foundries, glass works, wharves, and the Perkins Institution for the Blind.

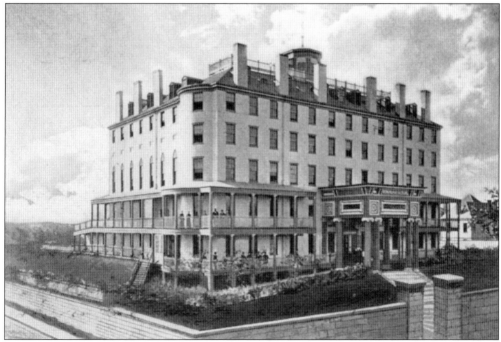

The Perkins Institution, named for Boston merchant Thomas Handasyd Perkins, was operated by Samuel Gridley Howe. Howe's education of Laura Bridgman, a deaf mute, ensured the success of his institution. Later assisted, and then succeeded, by his future son-in-law Michael Anagos, Howe was among Boston's most respected citizens.

Julia Ward Howe, wife of Dr. Samuel Gridley Howe, was noted in her own right. The author of the "Battle Hymn of the Republic," she was a reformist and a leading club woman who was venerated in late nineteenth-century Boston. In 1872, she established "Mother's Day," and lived to see it become a national holiday.

Samuel Gridley Howe was to direct the Perkins Institution for the Blind for nearly four decades "for the purpose of providing employment for those pupils who have acquired their education and learned to work, but who could not find employment and carry on business alone." A noted South Boston institution, it moved in 1912 to Watertown, Massachusetts, though a workshop remained on East Fourth Street until 1952.

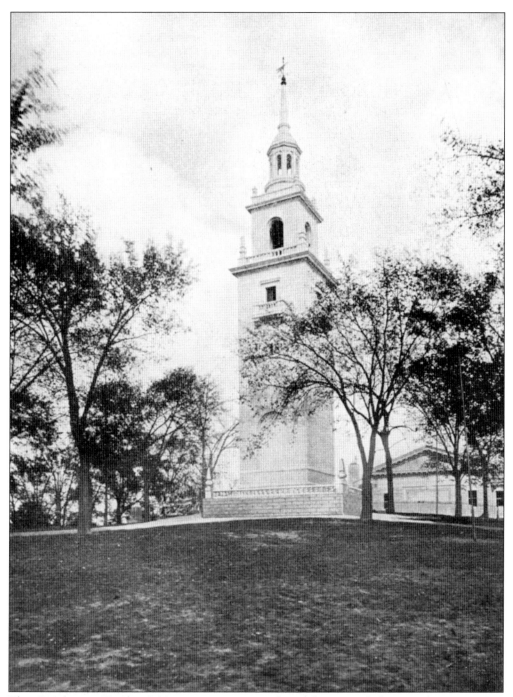

The Dorchester Heights Monument was erected on the site of the Revolutionary War encampment that led to the evacuation from Boston of the British troops and the Loyalists on March 17, 1776. A white marble monument, it was designed by the Boston architectural firm of Peabody and Stearns. Now operated by the National Parks Service, the Dorchester Heights Monument has recently undergone a massive restoration and its weather vane can be seen from miles around.

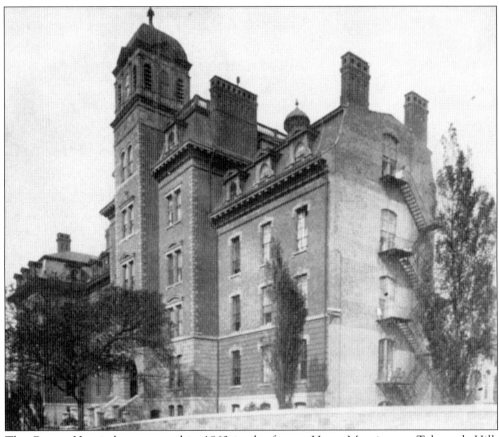

The Carney Hospital was opened in 1863 in the former Howe Mansion on Telegraph Hill. Established as a free hospital by generous citizens, it was later to be endowed by funds from Andrew Carney, for whom the hospital was named. Still serving the public, though now located in Dorchester, Massachusetts, the Carney Hospital was established for the "treatment of patients regardless of race, color or religion."

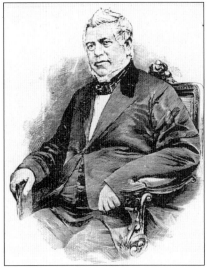

Andrew Carney is considered the founder of Carney Hospital through his great generosity. Known as "one of Boston's great Irishmen" and also as "one of God's best noblemen," Carney amassed a fortune through his clothing store, Carney and Sleeper, in Boston's North End. A total of $75,000 was donated to the Carney Hospital at the time of his death, and he was eulogized as "a kind-hearted, whole-souled, generous friend and protector to all."

After school the youth of South Boston could attend afternoon classes at the Little House which stressed domestic skills, dancing, and various clubs for all ages. Here, young girls arrive at the front door with their dolls.

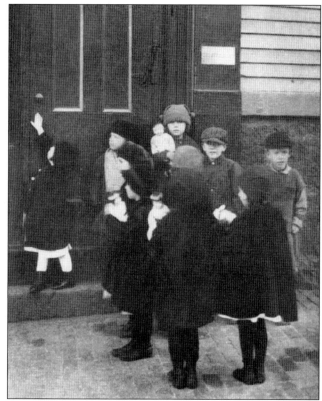

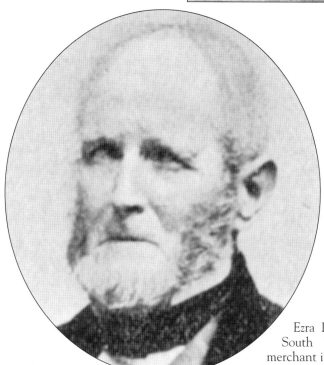

Ezra Perkins was a leading citizen of South Boston in the mid-1800s. A merchant in Boston, he owned a large estate in South Boston.

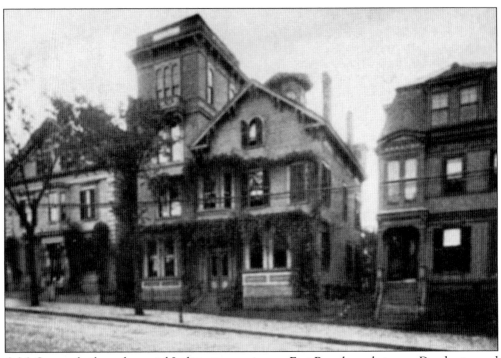

A.M. Stetson built a substantial Italianate mansion on East Broadway, between Dorchester and G Streets. The views of Boston and Dorchester Bay must have been superb from the soaring tower on the left.

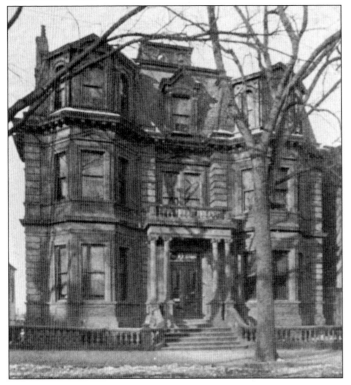

Dr. Michael F. Gavin, once a nationally-recognized surgeon, lived in this elegant brownstone mansion on East Broadway. A trustee of Boston City Hospital, Dr. Gavin was a well-respected physician who held memberships in the Boston Society for Medical Observation, the British Medical Association, the American Medical Association, and the Royal College of Surgeons, Ireland.

Henry J. Bowen's elegant brick and brownstone townhouse still stands on East Broadway next to Saint George's Cathedral (originally the Hawes Unitarian Church). Bowen was a real estate and insurance broker in South Boston and a trustee of several large estates. His uncle was Abel Bowen, whose book *Bowen's Picture Book of Boston* (1829) was engraved and published by him.

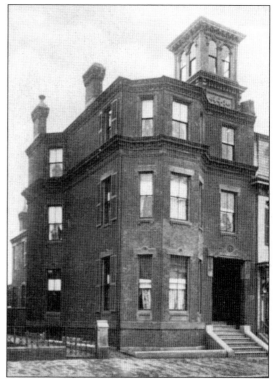

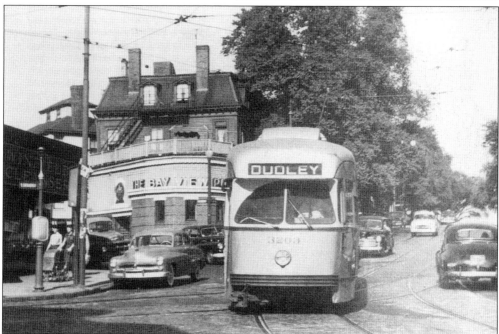

In the 1950s Perkins Square was serviced by trolleys that had overhead electric wires. This trolley is coming down East Broadway from City Point and is headed to Andrew Square, where it would continue on to Dudley Street Station in Roxbury. The Bay View Pub, to the left rear of the trolley, was a remodeling of an earlier shop.

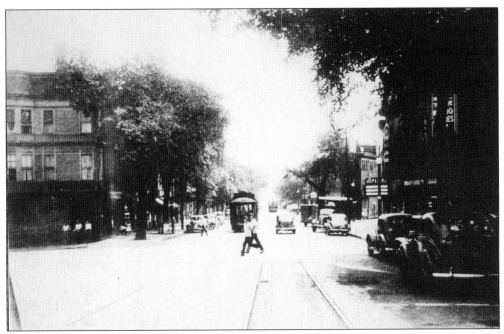

Flood Square is the junction of East Broadway and Emerson and I Streets. On the right can be seen the marquee of the Imperial Theatre. On the left, at the corner of I Street, are stores with apartments above. Notice the streetcar tracks and the lush overhanging trees along East Broadway.

Thomas Flood was a well-respected resident of South Boston and the representative for the community in the Massachusetts House of Representatives. The square was named in his honor in 1905.

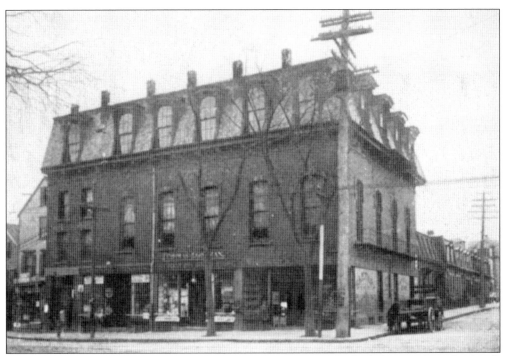

Gray's Hall was at the corner of East Broadway and I Street. The hall above, where the South Boston Citizens Association met for decades, was removed after World War II and the first floor remodeled for retail space. Note the workers' rowhouses on the right along I Street.

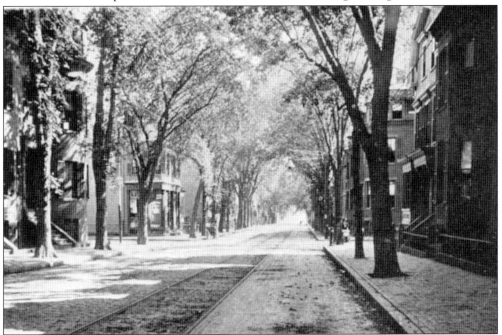

K Street, looking from Fourth Street, once had streetcars running its length. The street was built up with brick townhouses towards East Broadway, but with wood-framed free-standing houses toward Columbia Road. The mature trees added greatly to this still charming street.

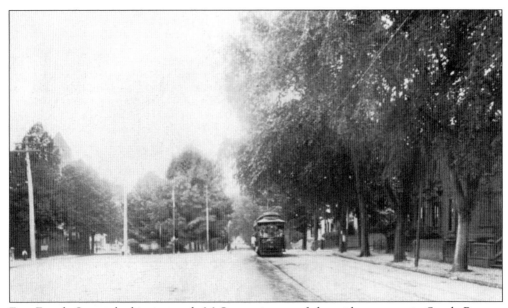

East Fourth Street, looking towards M Street, is one of the widest streets in South Boston. Originally, Emerson Park (in the center) was to be extended, but the cobblestoned street remained open. The substantial houses facing East Fourth Street were elegant and had lavish gardens shaded by massive trees.

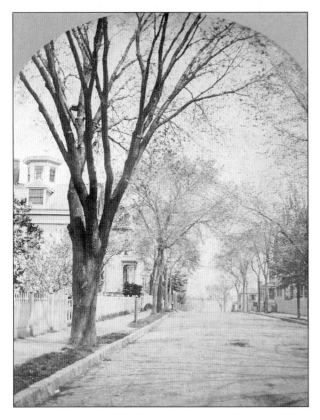

These free-standing Italianate houses at 372 (left) and 378 K Street were built at the time of the Civil War. They were only two blocks from the ocean, which can be seen in the distance just between the trees at the end of K Street.

William McCullough's house and garden was on Fourth Street. He once had charge of the flowers at the Boston Public Garden and "he made a national reputation by his introduction of the tomato into the United States." McCullough's home and garden, almost an acre between M and N Streets, was so lavish in its display of flowers that "it was common for the elite of Boston to visit the grounds and express their admiration of the picturesque scene."

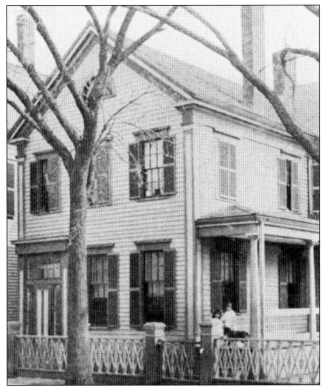

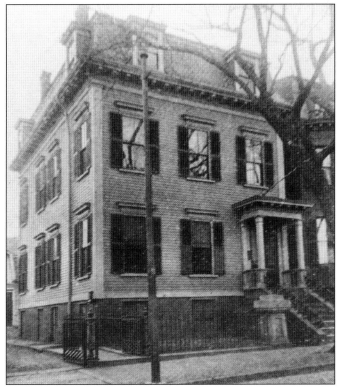

The City Point Catholic Association was located at 744 East Fourth Street. As South Boston's population continued to grow in the nineteenth century, many of the new residents were immigrants, and the children of immigrants, from Ireland. Here, the young men could meet for discussions, debates, parties, and just camaraderie.

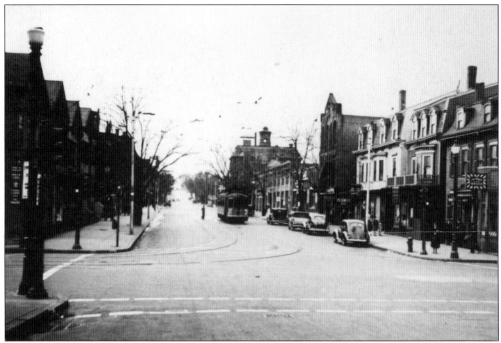

East Broadway, looking west from L Street, looks much the same today as it does here. Though somewhat remodeled, most of the buildings remain. On the right is the pedimented facade of the old Pilgrim Hall, recently remodeled as the Boston Beer Garden.

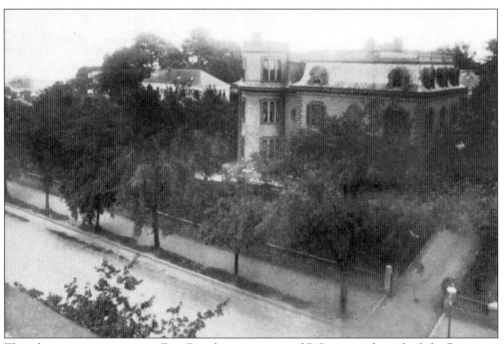

This elegant mansion was on East Broadway, just east of P Street, and was built by Benjamin Dean. An Italianate house with a mansard roof and corner tower, it was later demolished and a Colonial one-family house built on its spacious site.

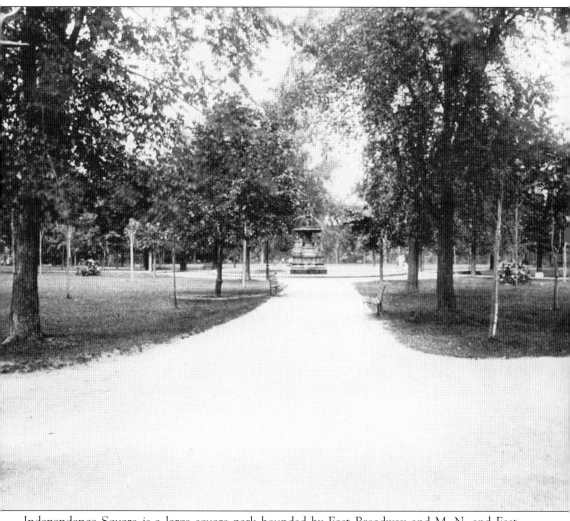

Independence Square is a large square park bounded by East Broadway and M, N, and East Second Streets. Laid out by the City of Boston much like the Public Garden in the Back Bay, Independence Square once had a large playing water fountain in the center with walkways bordered by shade trees and flower beds. The park has recently been the site of extensive work: new shade trees have been planted, and in 1981 the South Boston Vietnam War Memorial was erected on the site of the fountain. The memorial was the first of its kind to be dedicated in the United States.

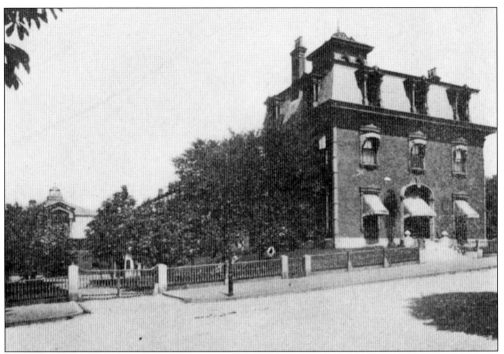

The Dana House is at the corner of East Broadway and M Street. Built following the Civil War, this fashionable Italianate brick and brownstone mansion with its mansard roof retains its large lot, bounded by a granite and cast iron fence. The carriage house, seen to the left through the trees, was necessary for the stabling of horses.

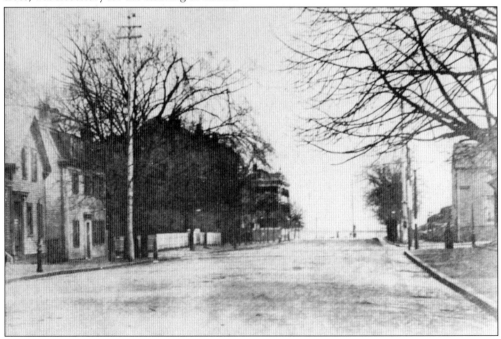

East Broadway, looking towards City Point from O Street, had small wood-framed houses that dated from prior to the Civil War in this 1885 photograph.

Four
South Boston Churches

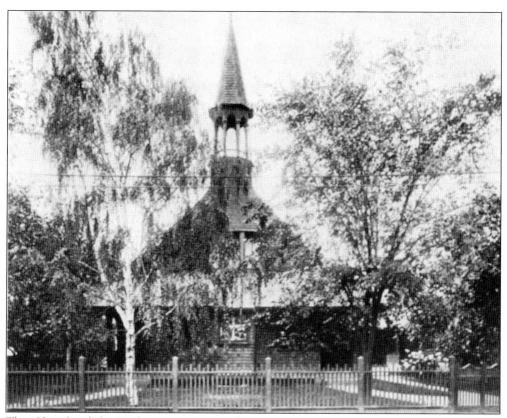

The Church of the Redeemer was a small Episcopal chapel under the direction of Saint Matthew's Church. In 1882, services began in Dean Hall in South Boston, and continued until this chapel was built in 1885 on East Fourth Street. The religious diversity of South Boston's population by the 1860s was as varied as their birthplaces.

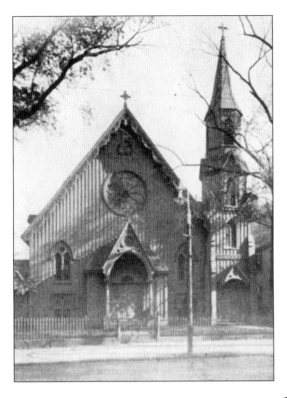

Saint Matthew's Church is South Boston's oldest Episcopal church. Though Boston embraced Episcopalianism as early as the 1720s, this church, a member of the Protestant Episcopal Church, was originally located on West Broadway near F Street. It later moved to East Fourth Street, where it currently is located.

The Hawes Unitarian Church was originally known as the Hawes Place Society. In 1810, John Hawes donated land on which to build a church for the residents of South Boston, and in 1832 he donated sufficient money to build a church at Emerson and Fourth Streets. Later, a larger church, now known as Saint George's Cathedral, was built on East Broadway. Reverend James Huxtable (shown here) was the pastor in 1900; he took a deep interest in the affairs of South Boston, and was among those endeavoring to preserve its moral tone.

44

The Broadway Universalist Church was on East Broadway next to the home of Dr. Gavin on "Pill Hill." Organized in 1835 at Lyceum Hall in South Boston, it was located at West Broadway and B Street until 1872, when it moved to its new site. Broadway Universalist was demolished in the 1960s, and today a vacant lot marks its site.

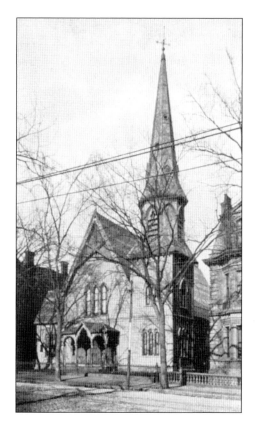

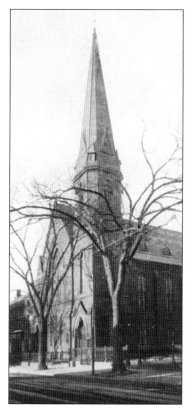

Saint John's Methodist Episcopal Church was originally at the corner of West Broadway and C Streets. It later moved further east on West Broadway, to the present site of the parking lot beside the Mount Washington Savings Bank.

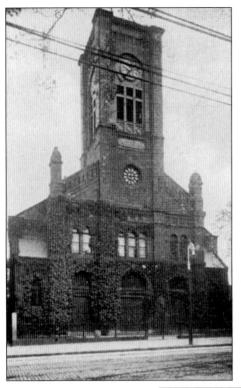

The Phillips Congregational Church, founded in 1823, was originally located on Fourth Street between D and E Streets. Shortly after being founded, the church erected an elegant meetinghouse at the corner of West Broadway and A Street. In 1879 the church moved again, this time to an impressive Victorian edifice it had built on West Broadway, on the present site of the parking lot next to the South Boston Savings Bank. Today, the Phillips Congregational Church is located on Atlantic Street.

The South Baptist Church was founded in 1825 as a branch of the Federal Street Church in Boston. In 1829, a new church building was erected at the corner of West Broadway and C Street, and the church remained there until a new building was built at the corner of L and Fourth Streets. The two Baptist Churches in South Boston, the South Baptist and the Fourth Street Baptist Churches, united in this building, which today is the site of senior citizen housing.

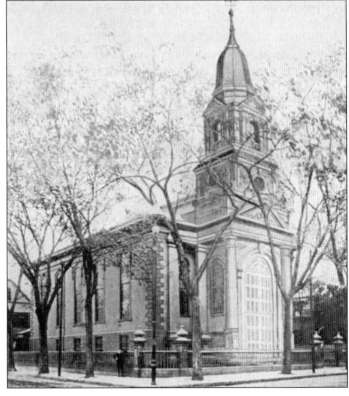

Organized in 1872, the Dorchester Street Methodist Episcopal Church was a stick-style wood-framed church built in 1889 at the corner of Dorchester and Vinton Streets.

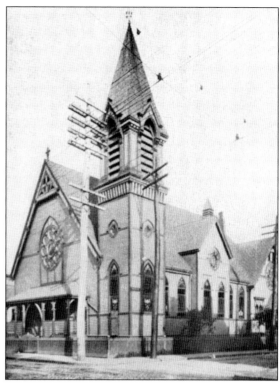

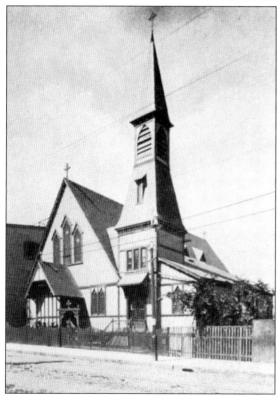

The Grace Episcopal Church was a simple church on Dorchester Street near Andrew Square. Founded by members of Saint Stephen's Church in Boston, which was destroyed by the Great Boston Fire of 1872, this church began services in 1875 and was named after the Grace Church of Brooklyn, New York.

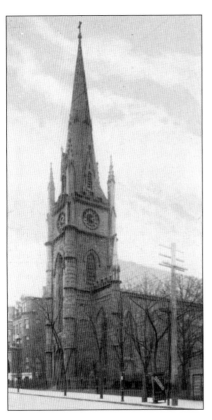

The Church of Saints Peter and Paul was founded in 1844. Originally designed by Gridley J. Fox Bryant, the church was destroyed by fire in 1848. When it was rebuilt, only the side walls of the original church, with their tall lancet windows, were reused. The massive granite stones used in building this church, the first Roman Catholic church in South Boston, gave it the look of permanence. Though a once thriving parish, and the second oldest Roman Catholic church in Boston, Saints Peter and Paul was closed on December 31, 1995.

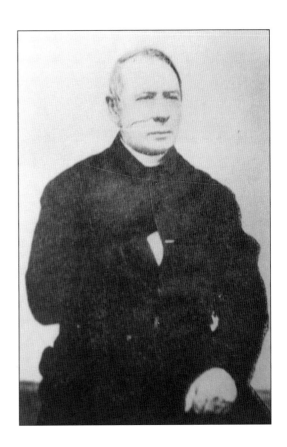

Father Terence Fitsimmons was the first pastor of Saints Peter and Paul on West Broadway.

The Church of Saint Vincent de Paul stands on E Street, between West Third and Bolton Streets. Originally built in Boston's Fort Hill district, it was moved stone by stone to South Boston in 1872 and re-erected as the second Roman Catholic church in the community.

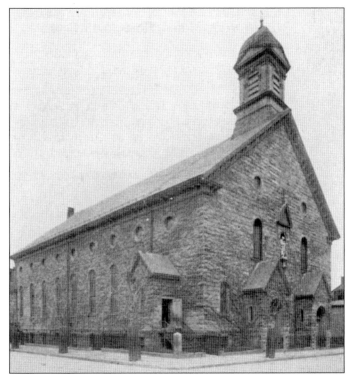

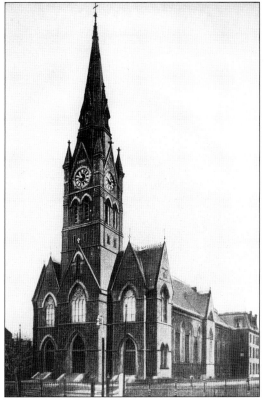

Saint Augustine's Church was built on Dorchester Street near West Eighth, and its 224-foot spire was completed in 1880. The parish includes the original Saint Augustine's Chapel, an 1818 Gothic chapel built in the midst of Boston's earliest Roman Catholic cemetery. The chapel, attributed to the architect Charles Bulfinch, is stark in its simplicity when compared to the Victorian church designed by noted architect Patrick C. Keeley.

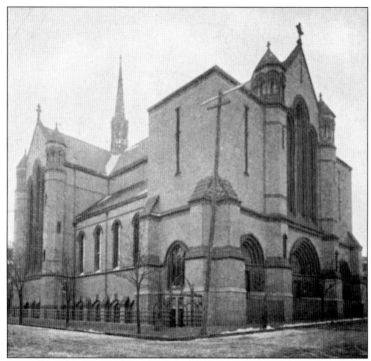

The Gate of Heaven Church was built in 1900 at the corner of East Fourth and I Streets, after fire destroyed the small 1863 chapel that had been used previously. An elegant church, its alter was designed by Ralph Adams Cram; the exterior use of buff Roman brick and the magnificent stained-glass windows, imported from Europe, still set it apart from the other churches in South Boston.

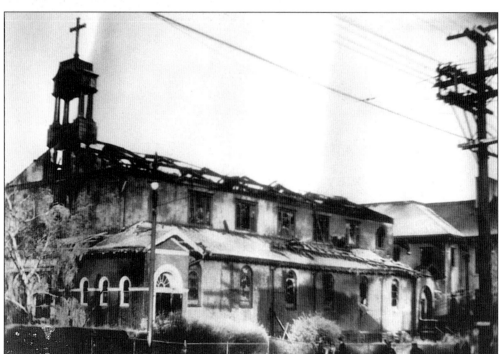

Saint Eulalia's Church was originally a mission of the Gate of Heaven Church and was located at the corner of West Broadway and O Street. A large church, it became an independent parish in 1908 and served the City Point area. It was later destroyed by fire and Saint Bridget's School was built on its site. (Courtesy SBHS.)

The Church of Our Lady of the Rosary was built on West Sixth Street between C and D Streets. It was located less than two blocks from the Saints Peter and Paul Church, which gives an indication of how many Catholics were moving to South Boston. The first mass was sung on Christmas, 1884, and the church survived until the D Street Housing Project swept away most of the neighborhood, including the church.

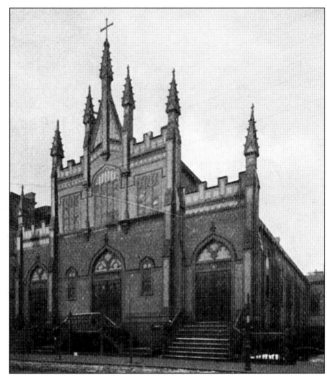

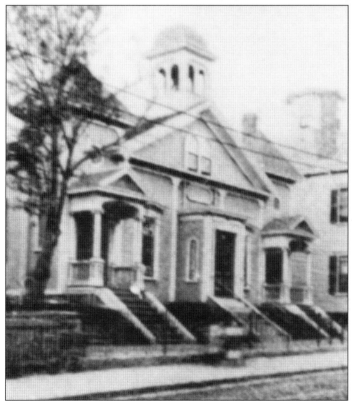

Saint Monica's Chapel was originally built on Dorchester Street, just outside Andrew Square. This chapel, now remodeled for housing, served the Andrew Square area until the present Saint Monica's Church was built at the corner of Old Colony Avenue and Preble Street.

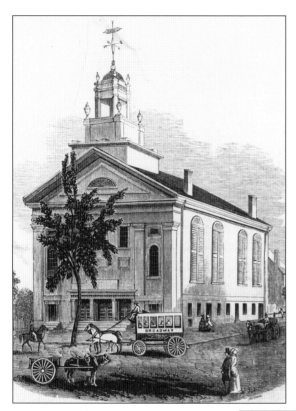

The South Baptist Church, a substantial wood-framed building that resembled many a New England meetinghouse, was located on West Broadway. Baptists, as members of the Protestant belief, practiced baptism of believers by immersion in water. The horse-drawn omnibus from Boston (known as the "Broadway") is shown here in front of the church. (Courtesy SBHS.)

The City Point Methodist Episcopal Church was built in 1878 at the corner of East Fifth and L Streets in City Point. A handsome stick-style shingle church, it had a small but very active congregation that supported it, and according to a news clip at the turn of the century, "the influence of this church is felt throughout City Point."

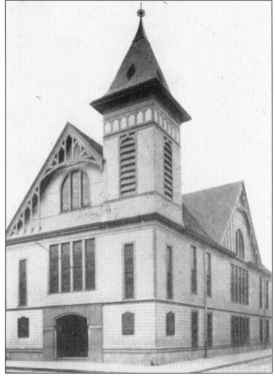

Five

Public Safety

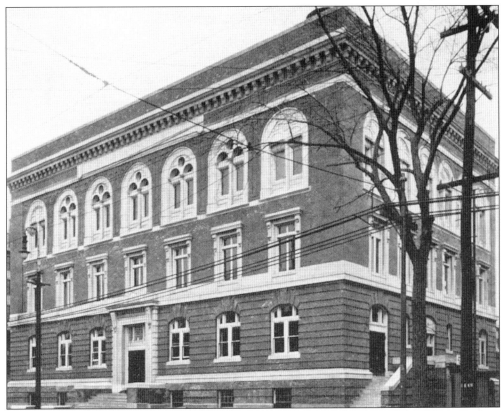

The South Boston Municipal Building was built in 1912 on the site of the former Perkins Institution for the Blind. Partly paid for by the profits from the City of Boston Printing Department, the building had an assembly hall, courthouse, library reading room, and public baths for men and women.

Patrick A. Collins was a well-known resident of South Boston, and served as a representative from the town in the Massachusetts House of Representatives. He later served as a member of the Massachusetts Senate and the U.S. Congress, and was ambassador to the Court of Saint James prior to his election as mayor of Boston.

James A. Gallivan was a resident of South Boston who worked in journalism prior to his election to the Massachusetts House of Representatives. From 1900 to 1914, he was the street commissioner for Boston, after which he served as a member of the U.S. Congress. Gallivan Boulevard, which runs from Dorchester to Brookline as Route 203, was named in memory of him in 1928.

The South Boston Courthouse was an impressive building at the corner of Dorchester and Fourth Streets. A brick and granite structure with a soaring iron-crested belfry, the courthouse was used until 1912, when the South Boston Municipal Building was constructed on East Broadway. To the left is Hook and Ladder No. 5.

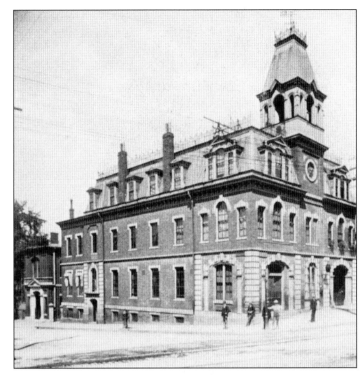

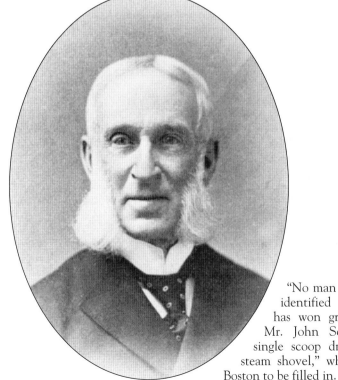

"No man born in South Boston and still identified with its business interests has won greater distinction in life then Mr. John Souther." Souther invented a single scoop dredge known as the "Souther steam shovel," which allowed the Back Bay of Boston to be filled in.

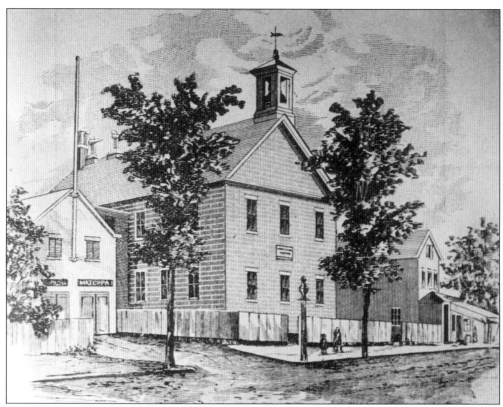

The Hawes School was on West Broadway near the corner of Dorchester Street. This school, named for local philanthropist John Hawes, was South Boston's first school. The first firehouse in South Boston was to the left of the school.

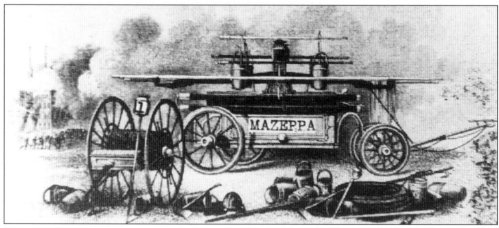

Mazeppa Engine No. 1 was South Boston's first fire engine. Known as a "hand pump," this engine would be drawn by horses to the scene of the fire and the tub filled with water from the leather fire buckets seen in the foreground. Once the tub was filled, the firemen would "pump" the levers of the engine to create a powerful force of water that could be sprayed directly on the fire and, hopefully, extinguish it.

Police Station No. 6, South Boston, was located on West Broadway. A brick and granite building, it not only had the perquisite jail cells for local offenders and rowdies, but ample space for the local policemens' offices and a ward room.

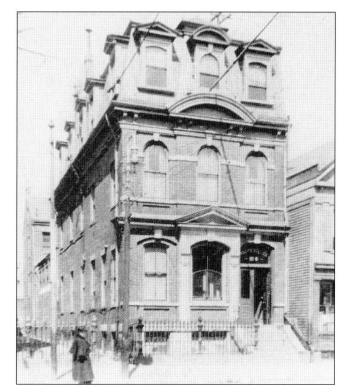

Captain Dennis Donovan was the captain of Police Station No. 6 on West Broadway in South Boston. Born in Ireland, he rose through the ranks of the police department, was a respected community member, and became an important leader, and role model, in the Boston Police Department.

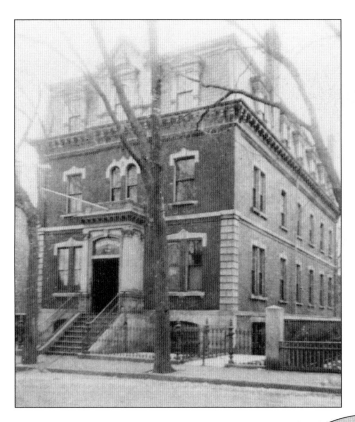

Police Station No. 12 was built on East Fourth Street, just west of K Street. The large brick and granite police station served the East Broadway and City Point areas of South Boston.

Captain Elijah J. Goodwin was captain of Police Station No. 12. Settling in South Boston in 1839, Goodwin initially served as a fireman prior to becoming a policeman. After serving as captain in South Boston for nineteen years, he retired and was presented with "a handsome plush chair," no doubt to rest in after a long career as a local law official!

Chemical 8 was a firehouse at the corner of B and Athens Streets. By the 1870s, chemicals, rather than water, were used to combat fires. The chemicals, sprayed from horse-drawn engines, proved more effective than the simple pump engines that used water. This building still stands next to the Hinds and Coon Company.

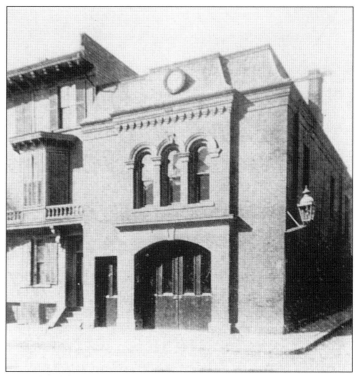

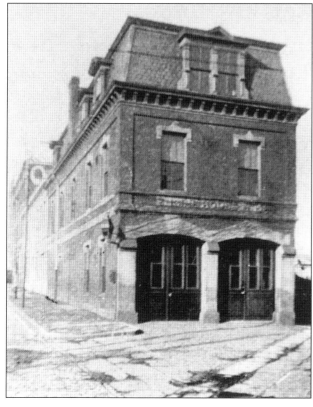

Engine 15 was located at the corner of West Broadway and Dorchester Avenue.

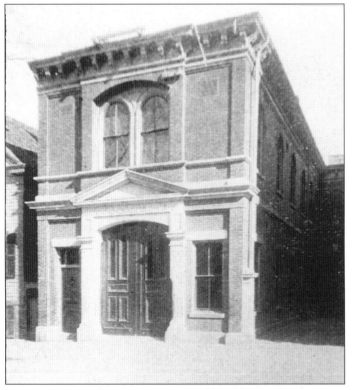

Hook and Ladder No. 5 was on West Fourth Street, directly behind the South Boston Courthouse. Today, the building has been adapted as the headquarters of the Dorchester Heights National Parks Service.

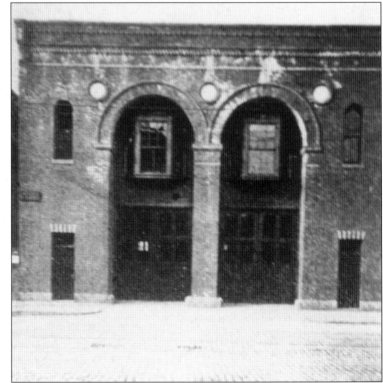

Engine 43 was located on Boston Street in Andrew Square. This simple, but impressive, firehouse had two soaring arches with firedoors set between them.

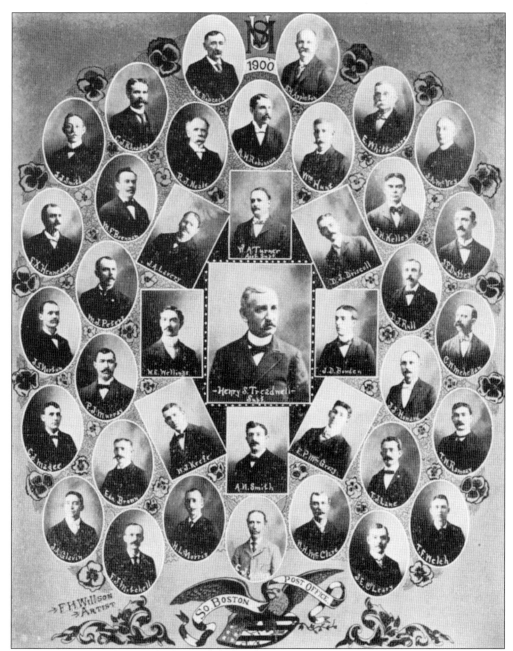

The employees of the South Boston Post Office were depicted by F.H. Willson in 1900. Henry S. Treadwell was the superintendent, or manager, at the time, and the photographs of the mail clerks, sorters, and letter carriers were arranged on this poster in an artistic manner. Though mail was received in South Boston during the early nineteenth century, it was not until 1849 that the postmaster of Boston started the "penny post" delivery of mail in Boston, South Boston, and East Boston.

Captain Harry Dawson succeeded Elijah Goodwin as captain of Police Station No. 12. His police badge was embossed "South Boston" and he continued the high level of service established by Goodwin. He proudly posed for this portrait in 1900.

George W. Armstrong was the owner of Armstrong's Express, a freight delivery service that operated throughout New England. Close in proximity to Boston, South Boston has always had many businesses that provided transportation service for the delivery and shipping of freight. Today, Bonney's Express, Inc. is one of South Boston's leading transportation companies.

Six
The Three R's

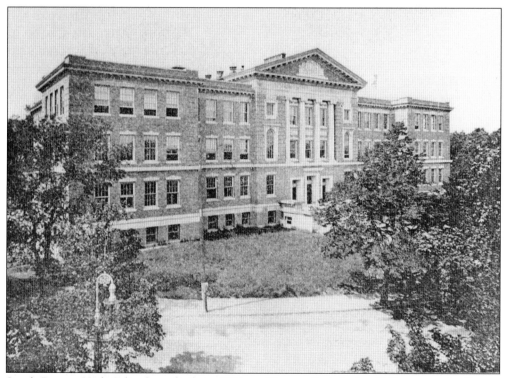

South Boston High School was built in 1901 on Thomas Park facing G Street, on the former site of the Telegraph Hill reservoir. An impressive yellow brick and limestone-trimmed school, it can be seen from almost every part of South Boston.

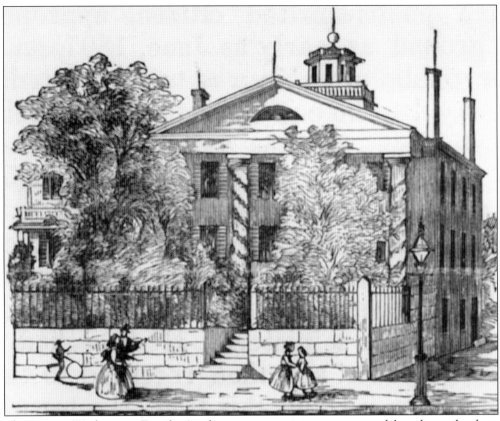

The Mount Washington Female Academy was a private seminary and boarding school on "Mount Washington," near the Perkins Institution for the Blind on East Broadway. Founded in 1835 by Mrs. Burrill, "every effort is made to store the minds of the pupils with knowledge, and to inculate in their hearts the principles of virtue and morality."

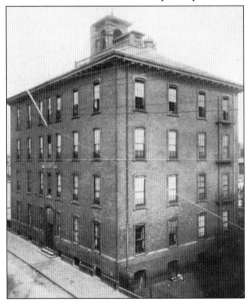

The Lawrence School was built in 1856 at the corner of B and Athens Streets. It was named after Amos Lawrence, a wealthy merchant and the person for whom the city of Lawrence, Massachusetts, was also named. The school was once the largest in Boston, but today it has been subdivided and is used by numerous businesses.

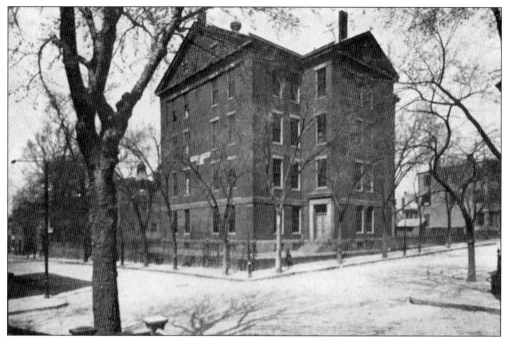

The Bigelow School was built in 1900 at the corner of F and Fourth Streets. Named for John P. Bigelow, the mayor of Boston from 1849 to 1851, the large yellow brick and limestone school replaced an earlier school. It was recently remodeled as the Bigelow Condominiums.

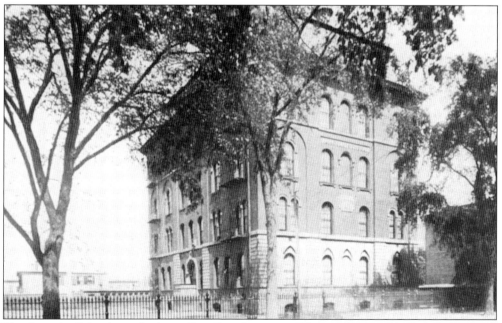

The Lincoln School was built on East Broadway in 1859, on the present site of the South Boston branch of the Boston Public Library and the South Boston branch of the Bank of Boston. An imposing four-story structure, it was named for Frederick W. Lincoln Jr., the mayor of Boston from 1858 to 1860 and again from 1863 to 1866.

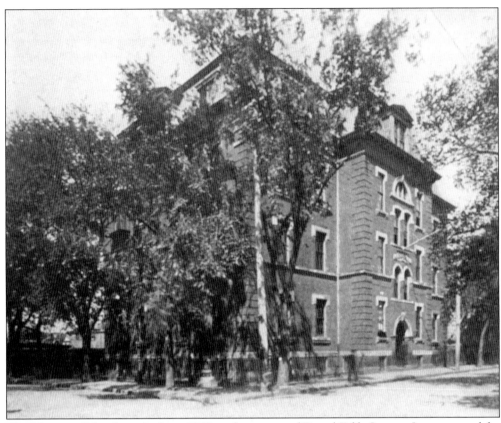

The Norcross School was built in 1868 at the corner of D and Fifth Streets. It was named for Otis Norcross, the mayor of Boston in 1867.

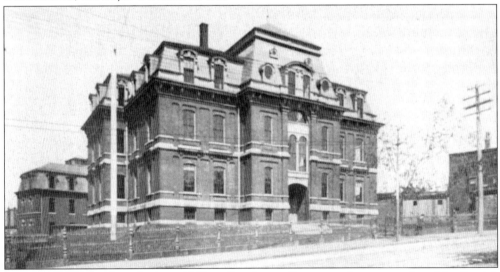

The Shurtleff School was built in 1868 on Dorchester Street, on the present site of the Patrick Gavin School. The school was named for Nathaniel Bradstreet Shurtleff, the mayor of Boston from 1868 to 1870 and the author of the important history book A *Topographical and Historical Description of Boston.*

The Gaston School was at the corner of L and Fifth Streets. Built in 1873, it was named for William Gaston, the mayor of Boston from 1871 to 1872.

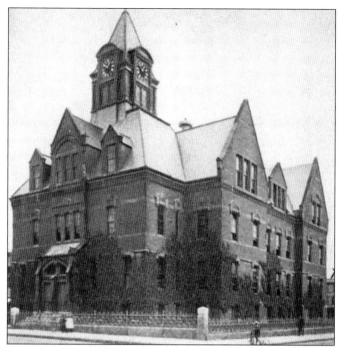

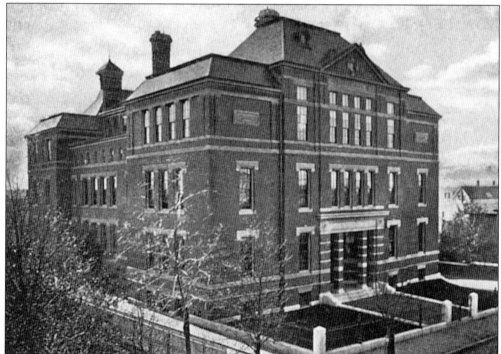

The John A. Andrew School was built in 1878 on Dorchester Street at the corner of Rogers Street. The school was named for John Albion Andrew, the governor of Massachusetts during the Civil War and the man for whom Andrew Square was also named. For many years, the basement of the school was used as the Washington Village branch of the Boston Public Library.

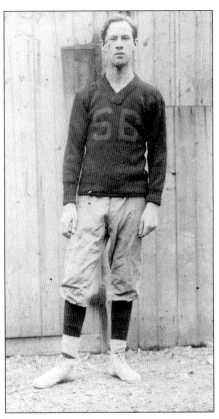

Bill Brown was an "All Scholastic" sports star and a student at the South Boston High School at the turn of the century. He posed for this photograph wearing his South Boston jersey in his backyard. (Courtesy SBHS.)

Students of Miss Helen Cohalan, a teacher at the Shurtleff School, posed for this class portrait in 1922 outside the school. It was not at all unusual that many of the classes were segregated, with boys and girls attending different schools. (Courtesy SBHS.)

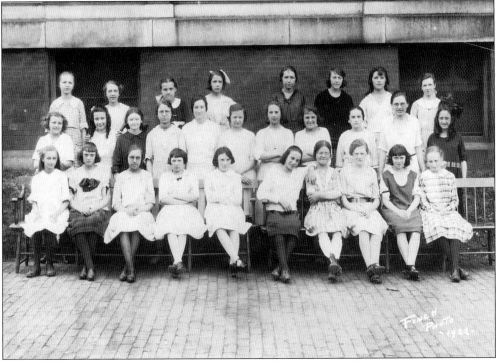

Seven
South Boston Industry

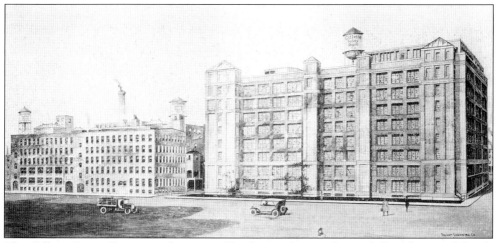

The Gillette Razor Company plant is on Dorchester Avenue between Broadway and South Stations. In 1901, King C. Gillette invented the "safety razor." It was said that "no invention of the nineteenth or twentieth century has brought greater freedom from the serfdom that surrounded millions of men of this and previous generations than the simple device patented by King C. Gillette when he conceived and protected from piracy the safety razor, which bears his name and which is daily employed by more people throughout the world than probably any article of every-day use."

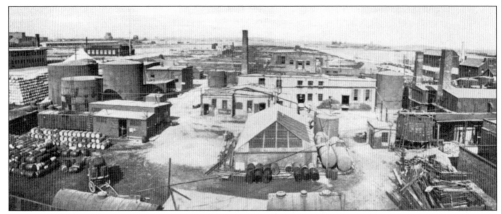

The oil works of the Jenney Manufacturing Company were extensive, and fronted on the harbor. With a reputation for its high-grade fuels, the "Jenney Manufacturing Company enjoys the distinction of being the only concern to-day [1900] that refines petroleum and manufactures burning oils in New England." Throughout the twentieth century, the "Jenney Oil Company" was a leading supplier of gasoline for automobiles.

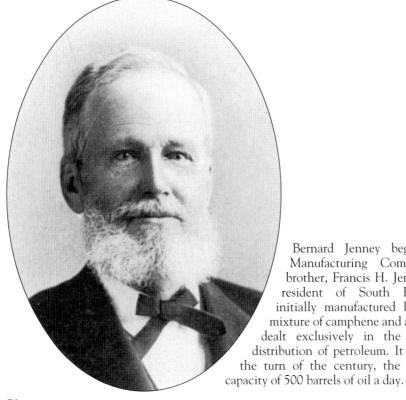

Bernard Jenney began the Jenney Manufacturing Company with his brother, Francis H. Jenney, in 1861. A resident of South Boston, Bernard initially manufactured burning fluids, a mixture of camphene and alcohol, before he dealt exclusively in the production and distribution of petroleum. It was said that by the turn of the century, the oil works had a capacity of 500 barrels of oil a day.

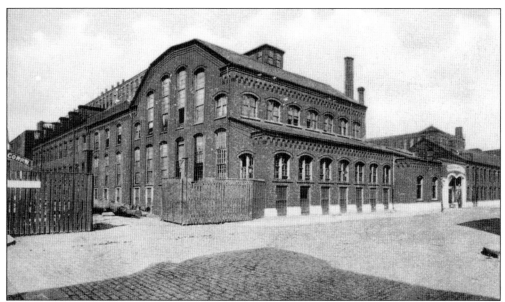

The Walworth Manufacturing Company, founded in 1842, was located on East First Street, near City Point. One of the largest manufacturing companies in South Boston, the "Walworth radiator" was a leading article on the market. The factory, which employed upwards of one thousand workers at any given time, covered many acres for the production of radiators and assorted supplies.

C.C. Walworth, an astute and highly-successful businessman, was the founder and president of the Walworth Manufacturing Company, and "invented the Walworth radiator which at once took a first place in the market and has always been considered one of its leading articles." After Walworth's death, Wallace Lincoln Pierce, his son-in-law, assumed the presidency.

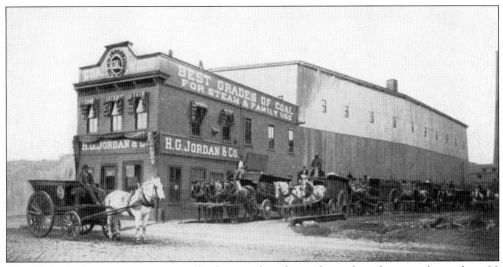

The H.G. Jordan Company was a leading coal and wood supplier that was located at 30 Dorchester Avenue in South Boston. These horse-drawn delivery wagons are ready to deliver the "Best Grades of Coal for Steam and Family Use" throughout the Boston area.

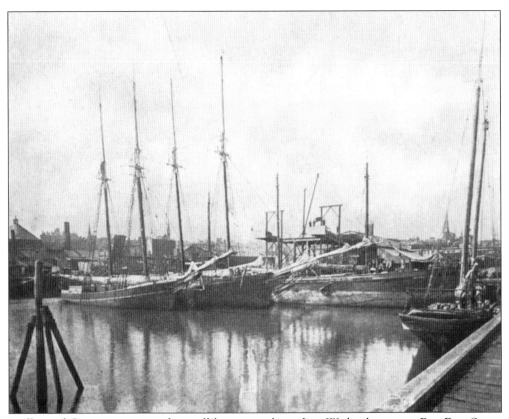

Mullin and Company was another well-known coal supplier. With wharves on East First Street opposite F Street, coal scuttles could dock at the piers and unload their cargo directly into the coal sheds built along the wharves.

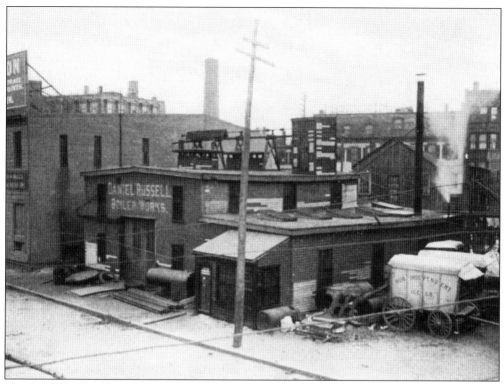

The Daniel Russell Boiler Works, located on Boston Street near Andrew Square, made a number of different things, including boilers, tanks and plate iron work for sugar refineries, gas works, water works, locomotive boilers, tender tanks, railroad structural work, and engineers' and contractors' specialties.

The works of Murray and Tregurtha, machinists, were located on East First Street. With proximity to the harbor, supplies and manufactured machinery could be received or shipped by water, as well as by rail, as the spur from the terminal that can be seen in the foreground indicates.

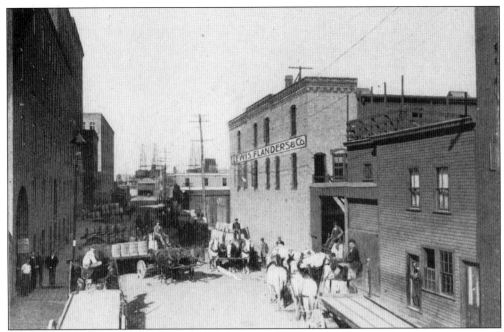

The Lewis Flanders and Company shop was located on Grant Street, opposite the American Sugar Refinery (which can be seen on the left). With horses and teams, Flanders and Company were among the leading teamsters in late nineteenth-century Boston.

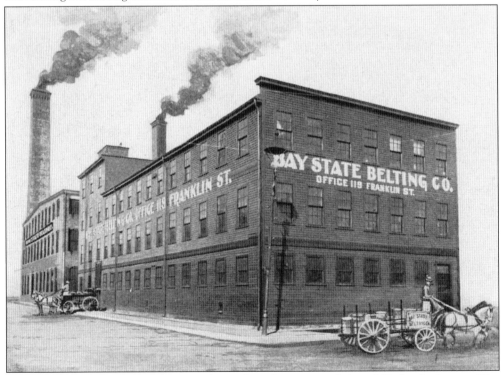

The Bay State Belting Company was located at the corner of A and Richards Streets. The factory turned out rubber belting of every size for businesses that used pulleys or conveyor belts.

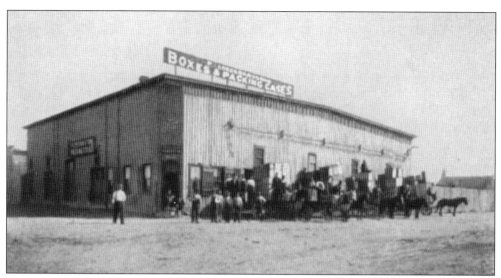

The box factory of P. Corcoran and Son was located on D Street. Started in 1872, the company annually turned out boxes and packing cases from over a million feet of lumber. Many of the employees posed for this photograph outside the factory, with the recently-made wooden cases piled on flatbeds awaiting delivery to businesses in Boston.

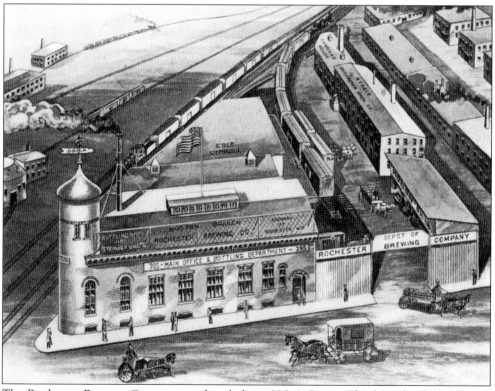

The Rochester Brewing Company produced ale at 295 A Street. This branch of the brewery based in Rochester, New York, was housed in a fanciful building with a circular tower surmounted by a weather vane. The sheds and cold storage facilities were adjacent to the railroad tracks that allowed for the large-scale distribution of the ale.

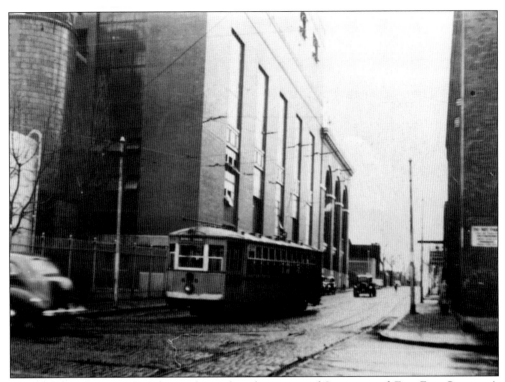

The Boston Edison Power Plant is located at the corner of Summer and East First Streets. A massive building, the tall smoke stacks along the waterfront can be seen for miles. The streetcar in the foreground is approaching the Summer Street Bridge that leads to Boston. (Courtesy SBHS.)

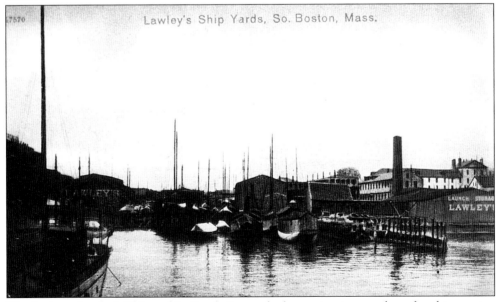

The basin at Lawley's Shipyard in South Boston had an extensive number of yachts nearing completion when this photograph was taken. With between two and three hundred workers, the shipyard was among New England's most progressive shipbuilding companies.

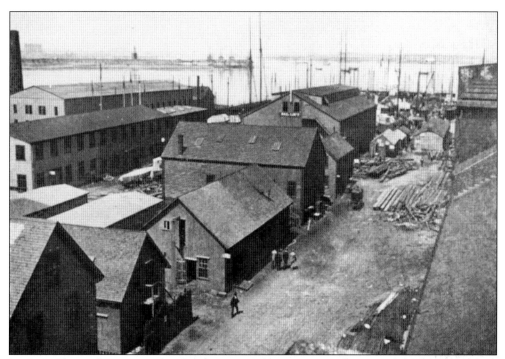

Lawley's Shipyard was opened in South Boston after George Lawley moved the operation from Scituate, Massachusetts. Located on East First Street, opposite O Street, the 7-acre shipyard built such important cup defenders as the *Puritan* and the *Mayflower*. "With the introduction of steel in combination with wood in the structure of vessels, known as composite construction, came the desire to be able to produce on the grounds the necessary steel work for this purpose."

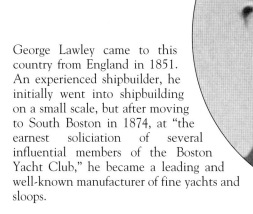

George Lawley came to this country from England in 1851. An experienced shipbuilder, he initially went into shipbuilding on a small scale, but after moving to South Boston in 1874, at "the earnest soliciation of several influential members of the Boston Yacht Club," he became a leading and well-known manufacturer of fine yachts and sloops.

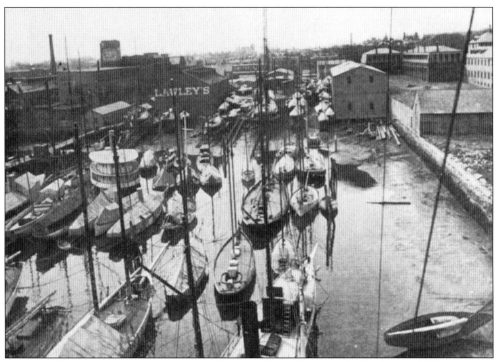

Looking from Boston Harbor towards City Point, the Lawley Shipyard ran along East First Street.

George F. Lawley went into partnership with his father and became president of the shipyard after his father's retirement in 1890. A progressive man, he was ably assisted by Thomas Hibbard and Edward Burgess, who were instrumental in ensuring Lawley's success.

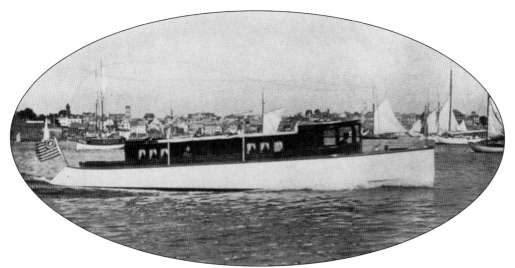

The launch *Scimitar* was produced in South Boston by the Murray and Tregurtha Company. It was 51 feet long and had a 20-horsepower gasoline engine.

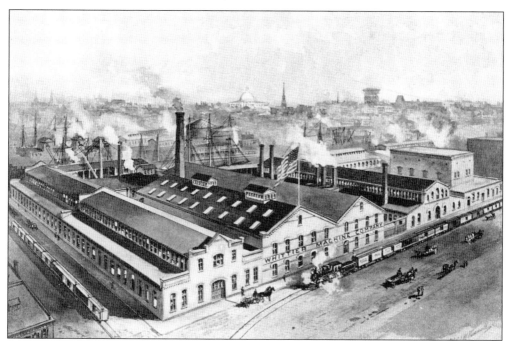

The Whittier Machine Company manufactured hydraulic, electric, steam, and belt elevators. It was located at Granite and East First Streets, in close proximity to Boston (note the dome of the Massachusetts State House in the rear).

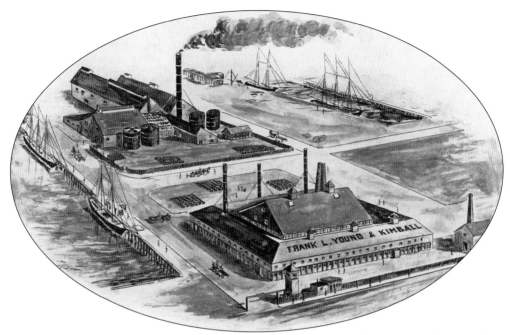

The factory and warehouses of Frank L. Young and Kimball covered 3 acres of land. Located on I Street, they manufactured and dealt in oils, grease, degras, wax, and many other products.

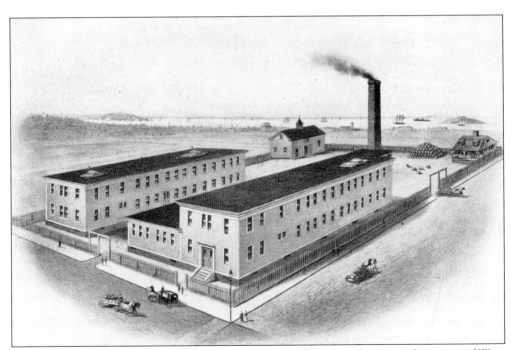

F.E. Atteaux and Company produced colors and chemicals at their factory at the corner of West First and D Streets. Today, this is the location of the Marr Scaffolding Company.

Eight
Congress, Summer, and East First Streets

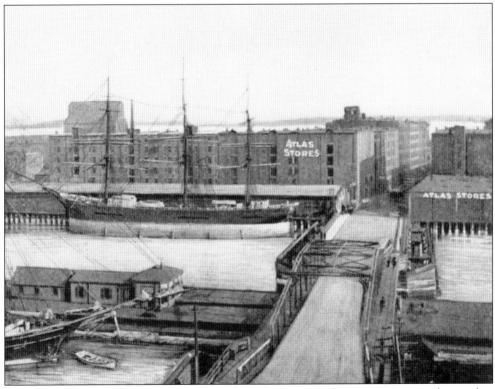

The Boston Wharf Company, seen from Congress Street, had an extensive warehouse that fronted onto the Fort Point Channel. The Congress Street Bridge (in the foreground) connected South Boston and Boston proper. Today the warehouse is the Children's Museum and the *Beaver*, of Boston Tea Party fame, is at anchor on the left.

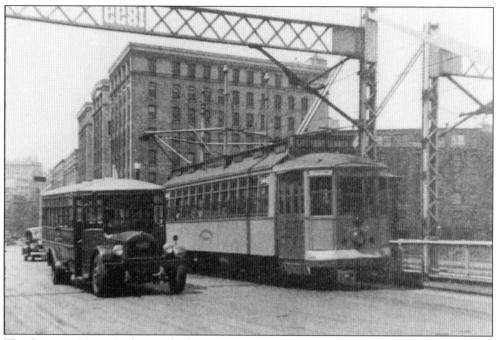

The Congress Street Bridge was built in 1899 to replace a wooden bridge, and it still serves as a major route from South Boston into Boston. Note the reversed date in the bridge's overhead.

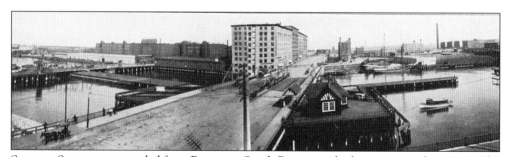

Summer Street was extended from Boston to South Boston in the late nineteenth century. The buildings on the left were part of the wool and garment manufacturing district. Today, the road that leads to the World Trade Center on Northern Avenue would be located on the right.

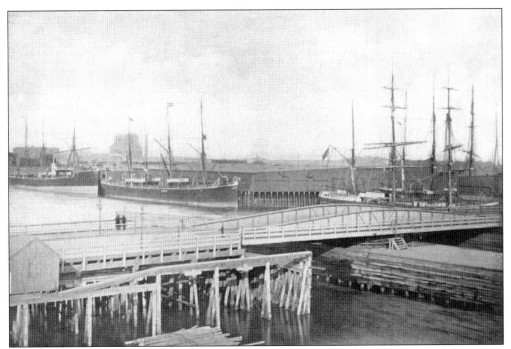

In this photograph of the Boston Wharf Company, taken from Mount Washington Avenue in South Boston, the extensive wood pilings that support the wharves and bridges can be seen, as well as ships soon to have their freight unloaded into the warehouses.

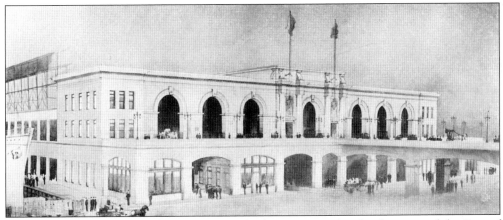

The Commonwealth Dock Head House was built in 1912 under the direction of the Port of Boston. An impressive dock, whose slogan was "Sail From Boston," it was 1,200 feet long, and was built to "accomodate at one time any two of the largest ocean steamships afloat and also two or three smaller vessels." Today, it is the World Trade Center.

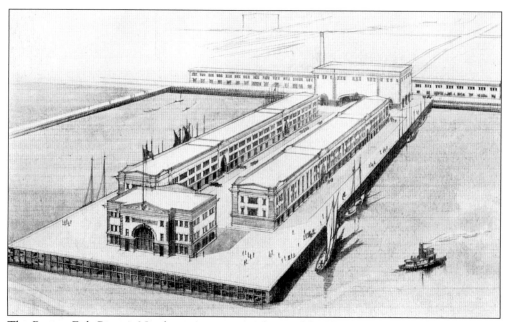

The Boston Fish Pier on Northern Avenue was designed by Henry F. Keyes and built in 1912 for the fish industry. A news clip of the time stated that, "To this location will be transferred the business now transacted at T Wharf," which was at the foot of State Street.

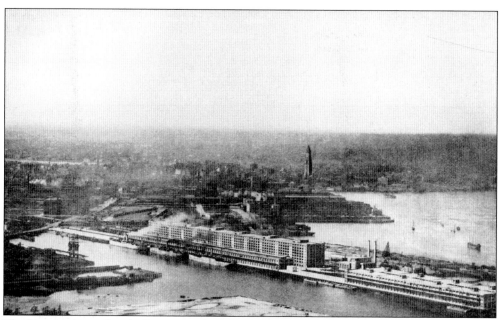

The Boston Army Supply Base, seen from an airplane in 1930, was an extensive grouping of buildings that were built on filled land off Summer Street. Today the Boston Design Center is located in this former base. The tower of the Boston Custom House, built in 1914 by Peabody and Stearns, can be seen rising in the background as Boston's only "skyscraper."

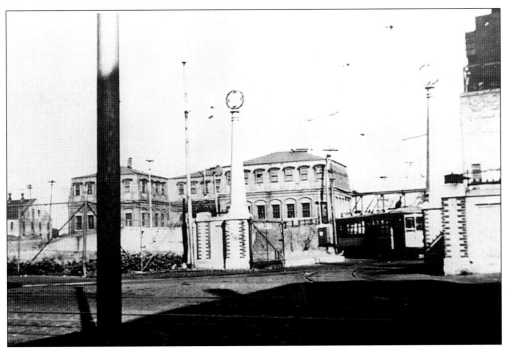

The car barns and storage facilities of the Massachusetts Bay Transit Authority were located on East First Street. The streetcar shown here is turning in the yard and will exit the gates onto East First Street. On either side of the entrance are piers surmounted by unusually attractive art deco lights. (Courtesy SBHS.)

Streetcars are pulled up on East First Street near City Point in the 1940s. In the distance is the present-day entrance to the Conley Marine Terminal. (Courtesy SBHS.)

A conductor operates a streetcar on East First Street, just having turned from Summer Street. On the right is the cement wall that shields the car barns and storage yard of the MBTA. The towering smokestacks are those of the Boston Edison Power Plant on Summer Street. (Courtesy SBHS.)

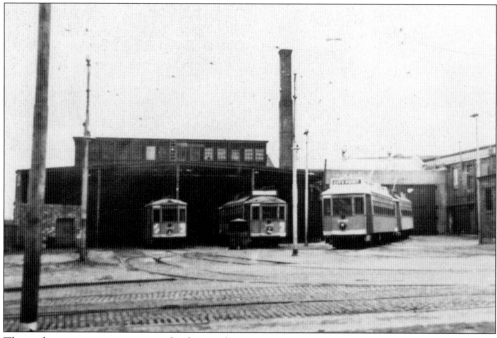

These three streetcars are outside the car barns on East First Street. Notice the cobblestone-paved street and the tracks that connected City Point to Boston. (Courtesy SBHS.)

Nine

The Saint Patrick's and Evacuation Day Parades

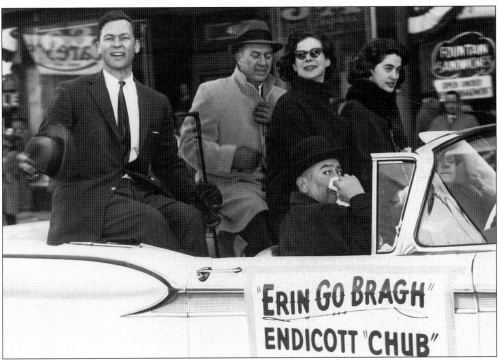

Endicott Peabody, or "Chub" as he was known, was a former governor of Massachusetts. Seated on the rear of a convertible with his family and supporters, he rode in the Evacuation Day parade that has been held annually in South Boston for decades. When General George Washington fortified Dorchester Heights during the Siege of Boston, he forced the British and the Loyalists to sail from Boston on March 17, 1776, which also happens to be Saint Patrick's Day. What better fun than to celebrate with a parade the evacuation of Boston on Saint Patrick's Day, and visa versa!

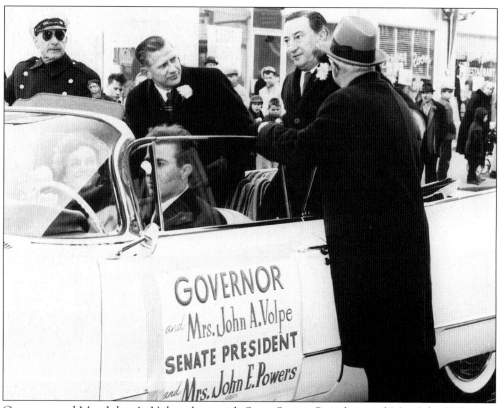

Governor and Mrs. John A. Volpe along with State Senate President and Mrs. John E. Powers ride in an Evacuation Day parade. Volpe was a proud son of an Italian-American family and an effective governor. Powers was born and raised in South Boston and became a leading force in the Massachusetts State House.

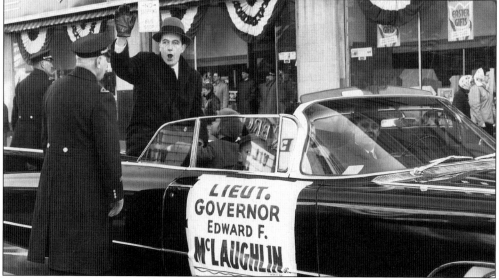

Waving to greeters, Lieutenant Governor Edward F. McLaughlin, and sons, are seen in an Evacuation Day parade outside F.W. Woolworth's on West Broadway.

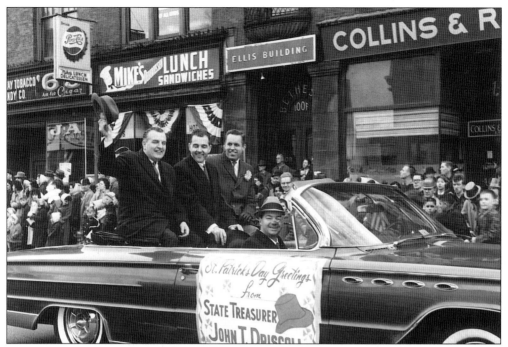

State Treasurer John T. Driscoll, in the middle, rides on the rear of a convertible. On the right, with the boutonniere, is Francis Crane, a later state treasurer of Massachusetts.

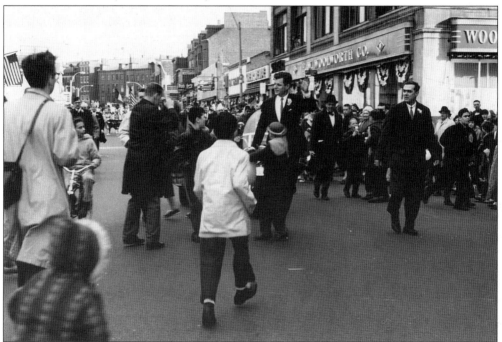

Senator Edward M. Kennedy walks down West Broadway during an Evacuation Day parade. The brother of President John F. Kennedy and Attorney General Robert Kennedy, Senator Kennedy was also the grandson of John F. Fitzgerald, or "Honey Fitz," a colorful mayor of Boston.

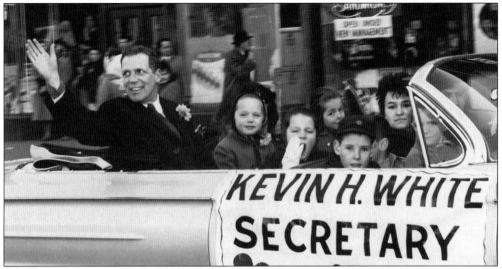

Kevin H. White, then secretary of state and later a mayor of Boston, and his family ride in a convertible. Though these parades were an important event in any politician's life, his daughter's yawning wasn't a good sign for voters! White later served as one of the more progressive mayors of Boston and began the massive rebuilding of the downtown and waterfront districts, with Quincy Market being developed as the major tourist attraction that it has since become.

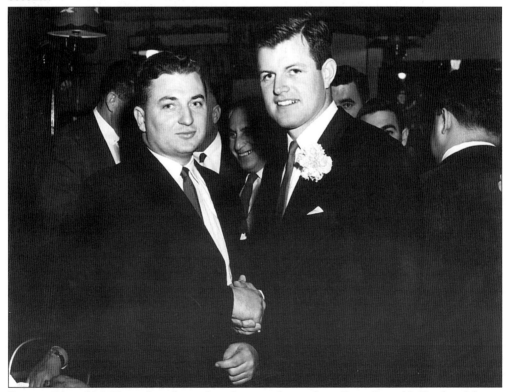

Senator Edward M. Kennedy is shown here being welcomed at a Saint Patrick's Day breakfast at Dorgan's Old Harbor House.

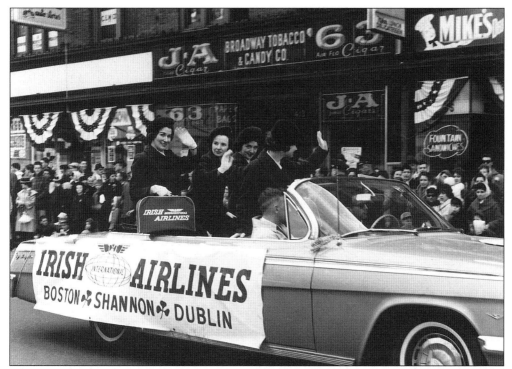

Even the stewardesses of Irish International Airlines got into the spirit. Here these comely lasses are dressed in their airline uniforms while waving to hopeful passengers who might visit Ireland. With direct routes from Boston to Shannon and Dublin, many descendants of those who immigrated from Ireland went "home" from time to time.

Dorgan's Restaurant was on Columbia Road, opposite the harbor. Although it was a popular restaurant, it became known statewide because of its annual breakfasts on Saint Patrick's Day. With hearty food, liberal libations, and convivial "bon mots," those who attended these annual events came not just as political rivals, but as friends.

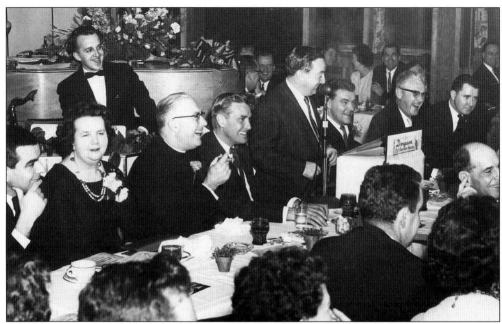

The head table at these infamous Saint Patrick's Day breakfasts attracted well-known civic leaders and elected politicians. Here State Senate President John E. Powers speaks from the rostrum to a packed dining room at Dorgan's. On the left is Louise Day Hicks, a member of the Boston School Committee and later a member of the U.S. Congress, the daughter of the late Judge Day, for whom Day Boulevard was named.

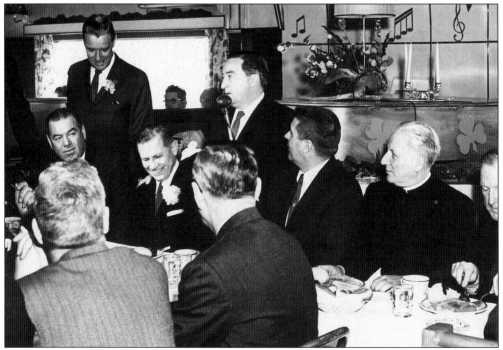

Undoubtedly, from the look on his face, Governor John A. Volpe is being lampooned in (one hopes) a good-natured way by State Senate President John E. Powers.

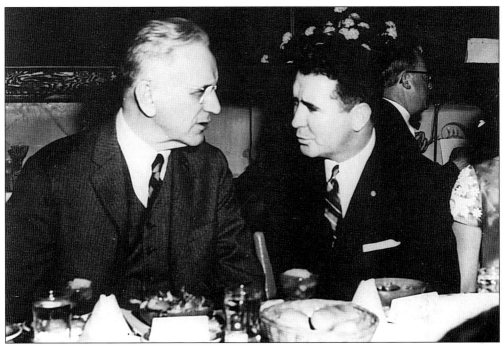

Congressman John McCormack, on the left, was born in South Boston and later became Speaker of the House. The McCormack Institute at the University of Massachusetts, just across the harbor, is named for him. The Strand Theatre in Upham's Corner in Dorchester was renamed the Harriet McCormack Center for the Performing Arts for Mrs. McCormack.

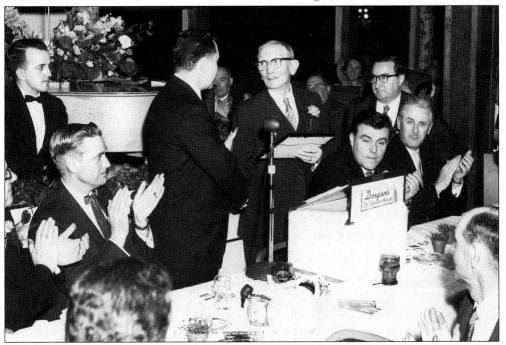

Recognition of both community work and long service were also a part of these breakfasts at Dorgan's.

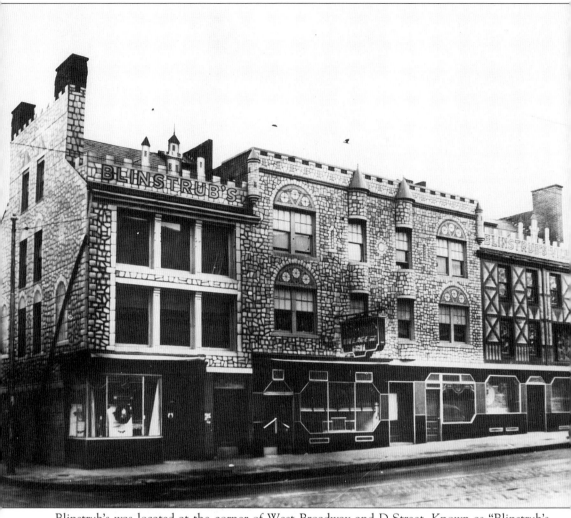

Blinstrub's was located at the corner of West Broadway and D Street. Known as "Blinstrub's Village," this castle-like restaurant had nightly entertainment with not just bands that one could dance to, but popular entertainers such as Frank Sinatra, Jimmy Durante, Patti Page, Connie Francis, and Judy Garland. The popular nightclub was destroyed by fire in 1968.

Ten
Marine Park and City Point

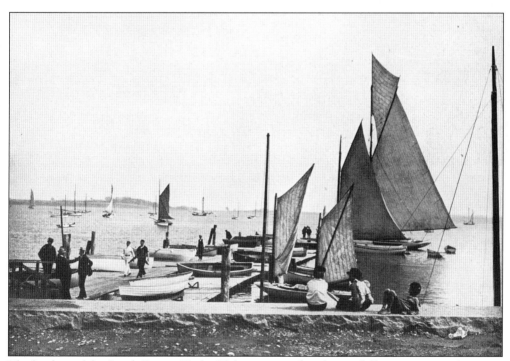

The landing of the South Boston Yacht Club was a popular place to loll on a summer afternoon, or to take a small boat that would allow you to get to your yacht at anchor in the harbor. This bucolic turn-of-the-century scene shows how popular yachting had become in South Boston, but also how attractive the area of City Point was to residents and visitors alike. (Courtesy SBHS.)

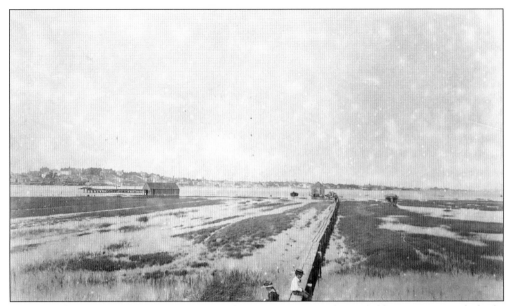

The flats, or marshlands, were the perfect place to fish. Here, these children sit on wood planks that have been extended from what is now Carson Beach on Columbia Road. On the left Dorchester Heights can be seen.

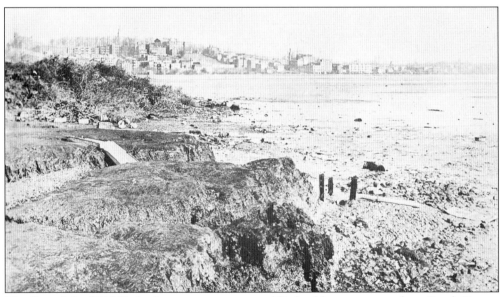

The flats of the "Old Harbor" were a menace to public health, as sewerage from South Boston and Dorchester emptied into them. So unsightly, and noxious, was the area that the City of Boston cleaned it up, created new beaches, and developed the Strandway (the wide walks of Columbia Road) that overlooked the harbor and the once odious flats. The tower of the Dorchester Heights Monument can be seen on the left, surmounting Dorchester Heights.

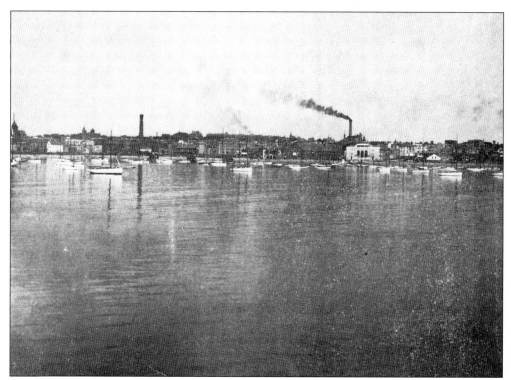

South Boston, seen here from the floating Life Saving Station, created quite an impression at the turn of the century. (Courtesy SBHS.)

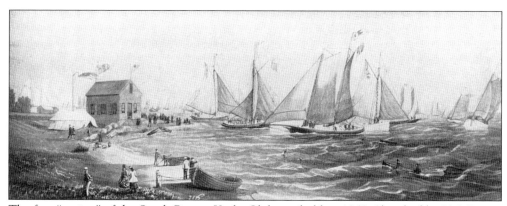

The first "review" of the South Boston Yacht Club was held in 1868. Sketched by J.M. Pierce, the yachts are shown here at the foot of K Street. The small wood-framed structure on the left was the first clubhouse of the South Boston Yacht Club.

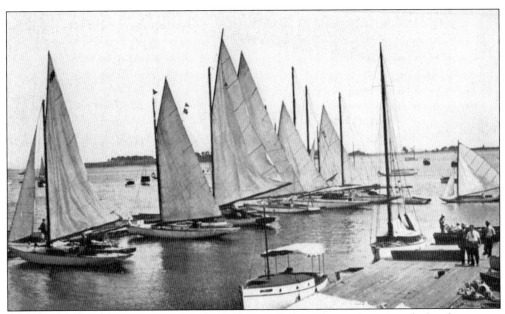

Members of the South Boston Yacht Club line up their yachts in formation before beginning one of the many races held during the summer. (Courtesy SBHS.)

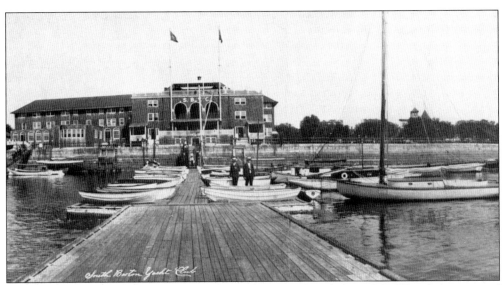

The South Boston Yacht Club, seen from the Bay, was founded in 1868, "For the purpose of encouraging yacht building and nautical science." With an extensive shingle-style clubhouse, members could participate in numerous club activities. On the right is the site of the public landing. (Courtesy SBHS.)

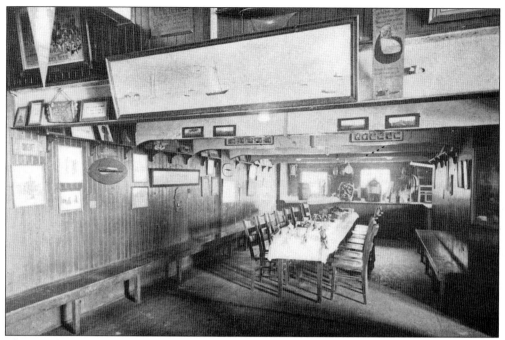

The Dutch Room of the South Boston Yacht Club was a dining room where members could entertain their guests. With nautical memorabilia lining the walls, and a fully-equipped bar at the far end, many an enjoyable evening must have been spent here. (Courtesy SBHS.)

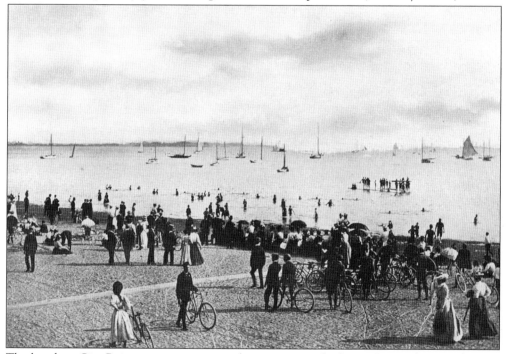

The beach at City Point was an attractive place not just to bathe in the sea, but to ride one's bicycle or promenade in the warm sunshine. The crowd, most of whom are fully dressed with boaters and parasols, gaze out at the swimmers and those diving from the launch in the harbor.

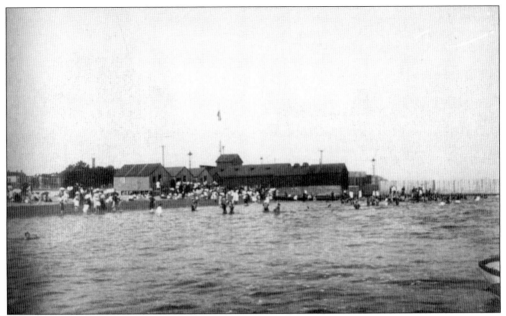

The K Street Bath House, on Columbia Road, was for women and girls. Separated from the men by a high wooden fence, bathers could enjoy the sun or swim segregated from the view of their husbands, sons, and fathers.

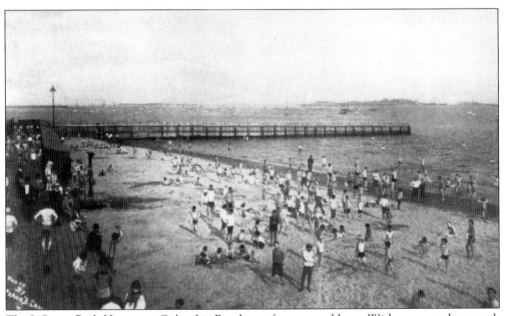

The L Street Bath House, on Columbia Road, was for men and boys. With separate, but equal, facilities for sunbathing and swimming, the bath house was a popular place and has, for almost the last century, been the site of the annual New Year's Dip of the "L Street Brownies."

By 1912, the City of Boston had laid out the Strandway, or Columbia Road, from Dorchester Avenue to Marine Park at City Point. This wide sidewalk followed the contours of the beach, and the Strandway's new automobile road had a "horse-less carriage" park for those visiting the beach and bath houses.

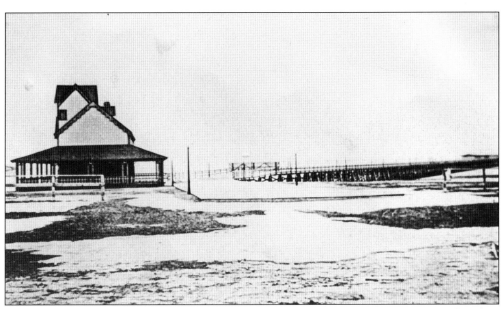

A temporary pier and refectory was built at Marine Park for those strolling along the beaches. The refectory offered shelter from the elements and a public restroom, while the pier projected out into Boston Harbor on pilings. (Courtesy SBHS.)

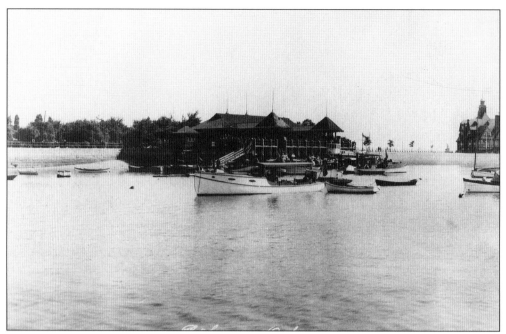

The Public Launch was a twin-capped pavilion that had a dock where launches could moor. Located on Columbia Road, opposite Farragut Road, it was a busy spot during the summer months. On the far right the Head House can be seen. (Courtesy SBHS.)

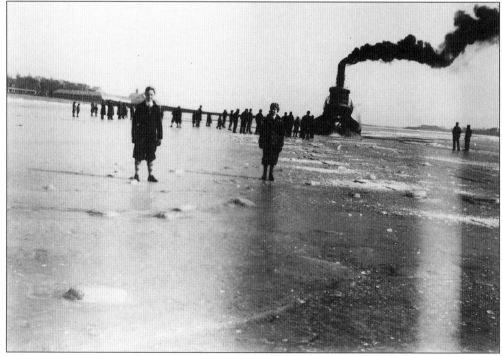

The harbor often froze solid during the winter, and here members of the Reid family pose for a photograph, *c.* 1920, as a tugboat breaks the ice. So solid and firm was the ice that people could walk out to Castle Island. (Courtesy SBHS.)

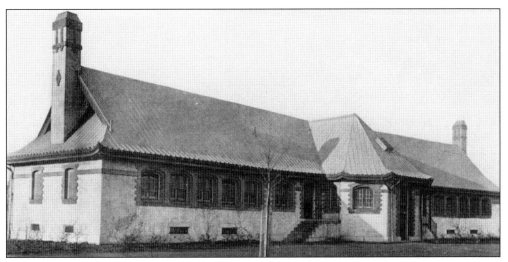

The playground building at Columbus Park was built by the City of Boston in 1911. A stucco, one-story structure, it has exotic, almost Chinese-inspired, roof corners and solid window quoining.

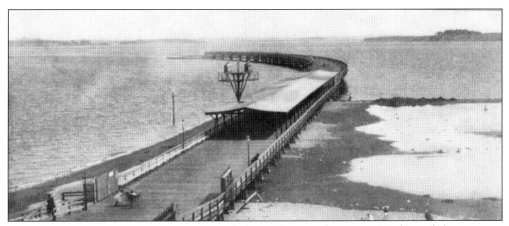

The Great Pier at City Point projected from the Head House. Wide and long in its construction, it had a roof-covered deck where dances were often held in the summer. Notice the observation tower that rises above the roof on the deck.

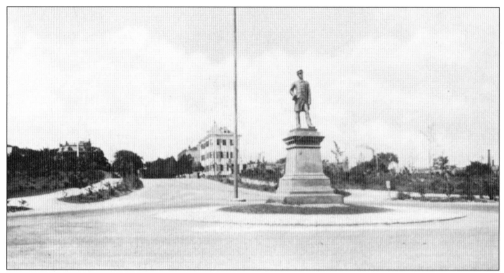

This statue of Admiral Farragut gazes toward the open seas from the rotary at Marine Park. David Farragut was a naval officer during the Civil War who commanded the flotilla which captured New Orleans in 1862. A respected man, his statue rises from a granite plinth base and commands attention by all.

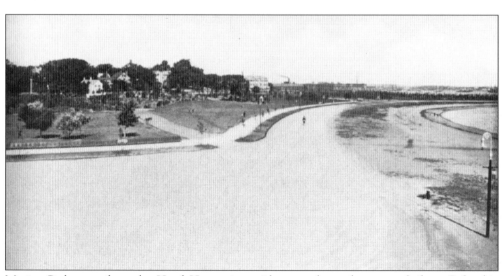

Marine Park, seen from the Head House, is a wide green lawn that extends from Columbia Road to East First Street. Bisected by East Broadway, it today has a bandstand where concerts are sometimes held in the summer.

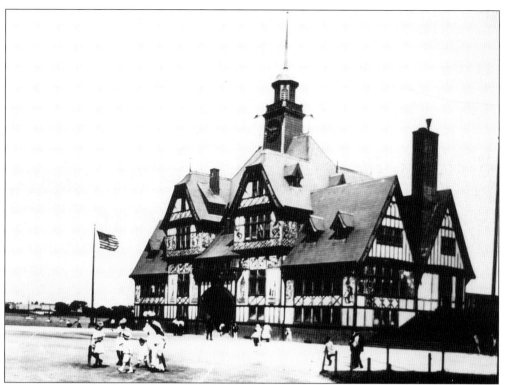

The Head House was designed by Edmund March Wheelwright after a German pavilion that had been built at the Chicago World's Columbian Exposition of 1893. An impressive building of timber and frame construction and polychromed designs, it was a place where one could listen to band music while enjoying ice cream. It survived until 1942, when it was destroyed by fire.

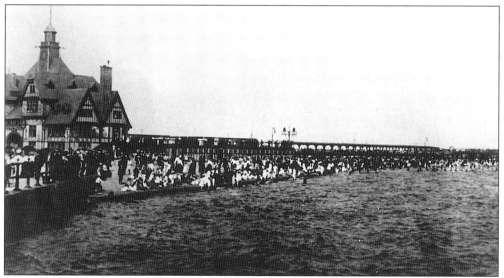

The beach at the rear of the Head House was filled to capacity during weekends in the summer. The rising roof line and projecting dormers of the Head House supported a cupola that had a soaring spire surmounted by a weather vane.

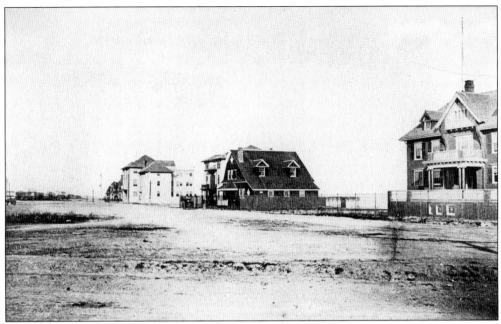

This photograph of the easterly end of Columbia Road, near Farragut Road, shows the many yachts clubs located here at the turn of the century. The clubs included the Boston Yacht Club (1866), the South Boston Yacht Club (1868), the Puritan Canoe Club (1887), the Mosquito Fleet Yacht Club (1888), and the Columbia Yacht Club (1896). (Courtesy SBHS.)

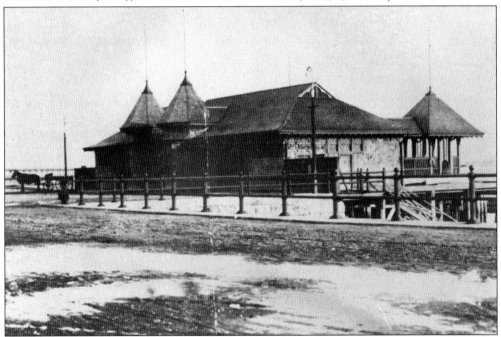

The Public Launch, seen from Columbia Road, faced Farragut Road. This shingle-style building had steps that descended to floating launches where people could alight from their yachts. A delivery wagon stands ready on the left. The iron balustrade still protects passersby from the steep walls of the beach.

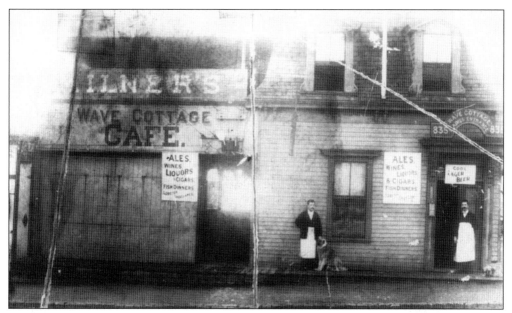

The Wave Cottage Cafe, serving "ales, wines, liquors & cigars and fish dinners," was located at the corner of P and Sixth Streets in City Point. Two waiters and a dog are shown here outside the ladies' entrance. Today, the Farragut House Restaurant is located on the site of this inn. (Courtesy SBHS.)

A rambling wood-framed building, the Peninsula Hotel was located at City Point, between P Street and Marine Park, opposite the Wave Cottage Restaurant (on the right). In the distance, between the buildings, the Public Launch can be seen. (Courtesy SBHS.)

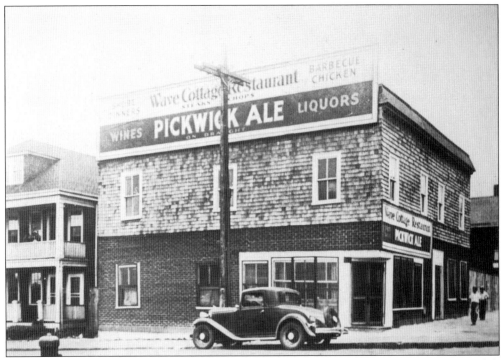

The Wave Cottage Restaurant was built on the site of the Wave Cottage Inn. Serving fish dinners and barbecued chicken, it was better known (before and after Prohibition) for its wines, liquors, and Pickwick Ale.

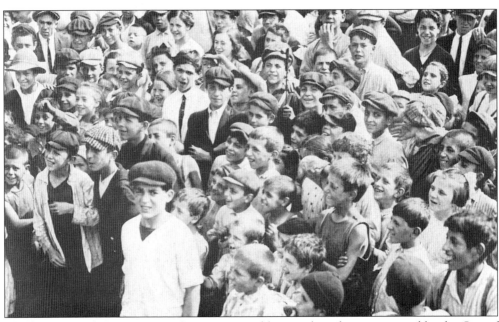

Children in South Boston were often entertained by traveling shows sponsored by the City of Boston. This group of youngsters is watching a "Punch and Judy" show at City Point in 1912.

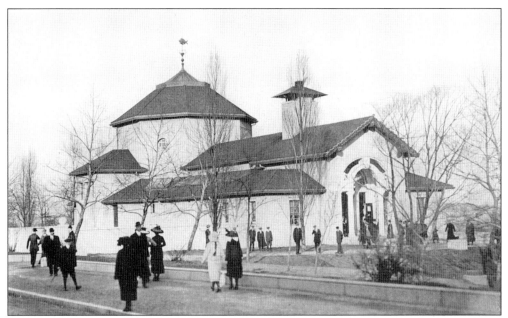

The Aquarium at Marine Park was opened in 1912. Built by the City of Boston from income derived from the Parkman Fund, it was a popular and exciting place to visit for children and adults alike. These visitors are approaching the stucco building, whose cupola is surmounted by a fish weather vane.

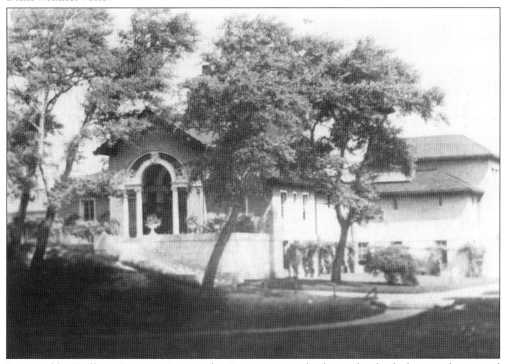

Designed by William Downer Austin, the Aquarium was built amidst the lush green lawns and trees of Marine Park. The entrance, facing the park, was flanked on either side by flower-filled urns.

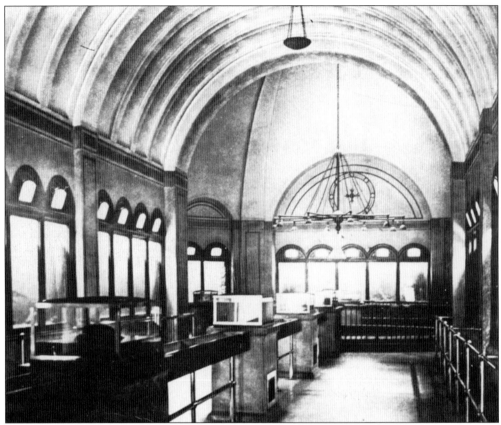

The interior of the Aquarium had water-filled tanks that contained a wide variety of aquatic life. These tanks, holding hundreds of gallons of water, could be viewed in a succession of rooms. Here, in a barrel-vaulted room, the attractions were obvious. Though a popular and well-attended destination, the Aquarium was demolished in the 1950s. The Boston Aquarium on Long Wharf in Boston is its successor. (Courtesy SBHS.)

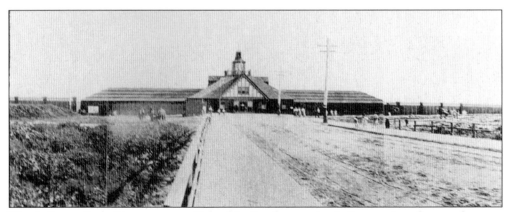

The L Street Bath House was on Columbia Road, opposite L Street. A pedimented center pavilion of post and beam construction, it had flanking wings. This attractive bath house was later replaced by the brick and limestone bath house that is presently on the site.

Children pose outside the entrance to the Aquarium in the 1940s. While it existed, school trips always included a visit to the Aquarium, where the excitement of seeing exotic and rare fish was almost as great as being out of school on a day trip!

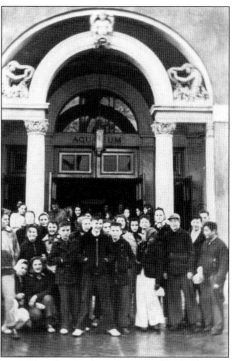

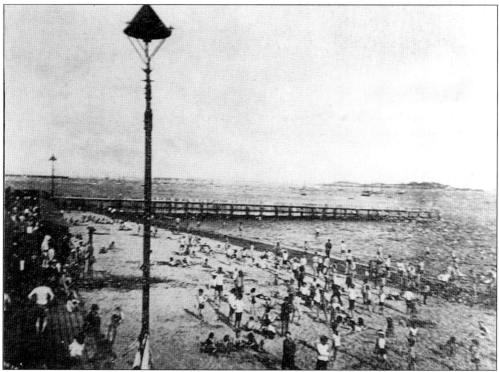

At the turn of the century the L Street Bath House had bathing and swimming facilities, but after the new bath house was built, it had showers, saunas, and men and boys going au naturel on the beach.

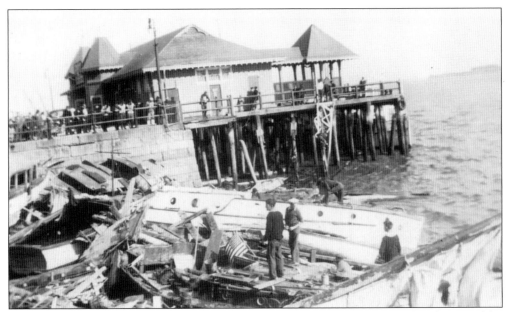

The Public Launch held its own during the Hurricane of September 21, 1938, but the rest of the area did not fare so well: the storm destroyed many buildings, uprooted trees, and tossed boats and yachts against the granite walls as if they were toys. Here onlookers assess the damage after the storm. (Courtesy SBHS.)

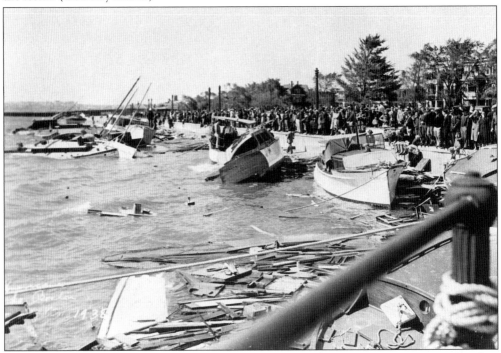

Looking west from the Public Launch, the hurricane had beached dozens of boats and yachts. Hundreds of people turned out the day after the hurricane to see the extensive damage. On the right, shaded by the trees, can be seen the three-deckers along Columbia Road. (Courtesy SBHS.)

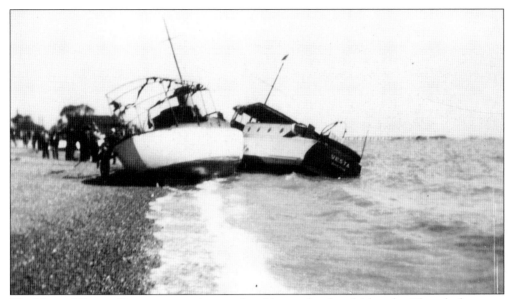

The *Vesta* of Boston lies on a precarious angle aside another beached yacht. Though the water seems calm in this photograph, the Hurricane of 1938 had waves of 10 feet and higher. (Courtesy SBHS.)

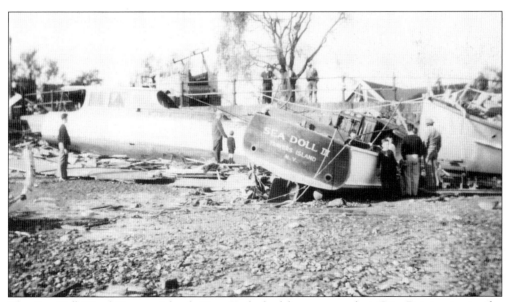

The *Sea Doll III* of Trevers Island, New York, had been moored at City Point prior to the Hurricane of 1938. Tossed ashore by the ferocious waves, it joined many other yachts, some of which had been reduced to timber. (Courtesy SBHS.)

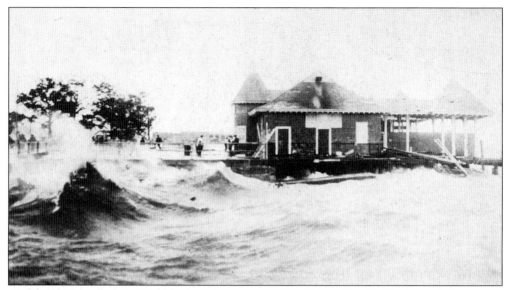

Another hurricane in 1954 lashed at the coast of City Point. The Public Launch, known as "Kelly's Landing" by the time of World War II, sustained damage from the intensity of the wind and waves. Pilings were torn away on both sides of the launch, undermining its stability. (Courtesy SBHS.)

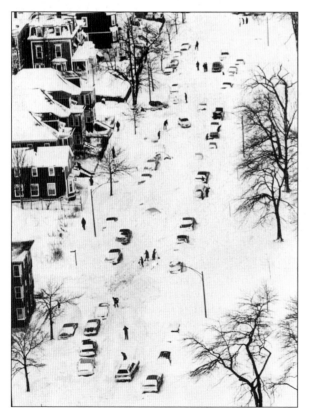

The Great Blizzard of 1978 blanketed Boston with upwards of 2 feet of snow. Many motorists were stranded and abandoned their cars on the roads. Boston was at a standstill for nearly a week while removing snow. Residents of City Point are shown here beginning the arduous task of "digging out." (Courtesy SBHS.)

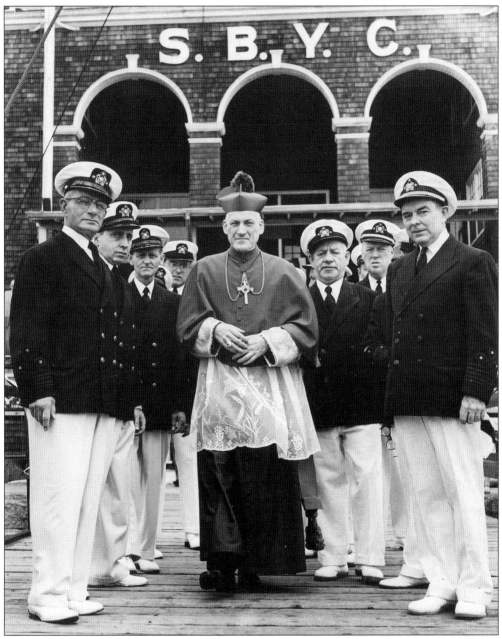

Richard Cardinal Cushing was born at 806 East Third Street and raised at 44 O Street in South Boston. The son of Patrick and Mary Dahill Cushing, he was an affable, erudite, and beloved priest, known not just locally but throughout the world. Here Cushing poses with his marine escorts outside the South Boston Yacht Club prior to saying Mass during a Marian Day ceremony. (Courtesy SBHS.)

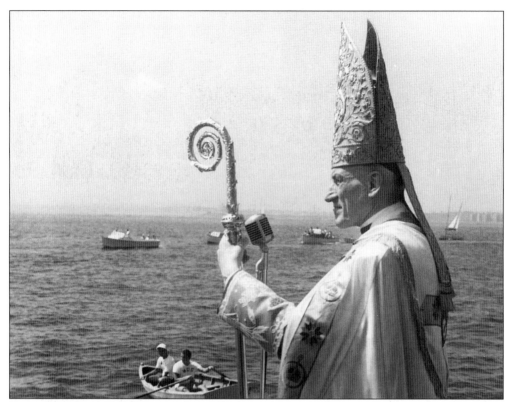

Richard Cardinal Cushing, gazing towards the open sea, stands erect with his miter and staff of office. A graduate in 1921 of Saint John's Seminary, he was elevated to the title of cardinal in 1958 by Pope John XXIII, and is shown here resplendent in vestments of silk and fine lace. Those who came to hear him also arrived by yacht and, in the foreground, by rowboat. (Courtesy SBHS.)

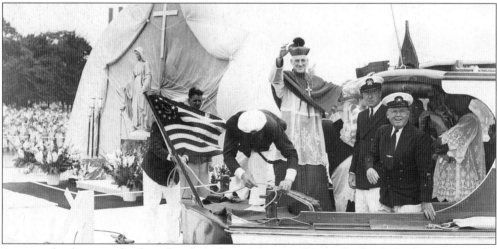

Arriving by boat at the launch where he was to say Mass, Cardinal Cushing greets the thousands of devout Roman Catholics who not only lined the shore but were in boats and yachts in the harbor. Cushing is flanked by officers who escorted him by boat. (Courtesy SBHS.)

116

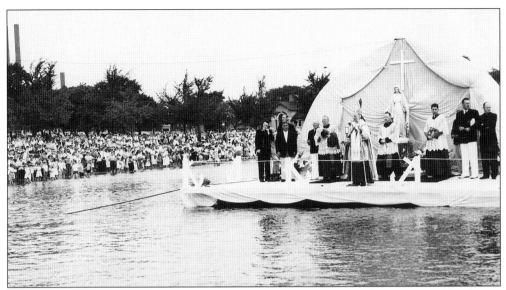

Richard Cardinal Cushing, the "World's Cardinal," says Mass on a floating launch off Marine Park during a Marian Day ceremony. Devout Roman Catholics line the shore, some actually standing in the water, while Cardinal Cushing speaks into a microphone. (Courtesy SBHS.)

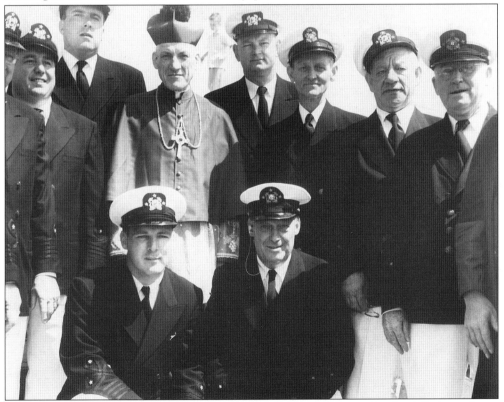

After Mass, Cushing poses with members of his naval escort. Meeting Cardinal Cushing always put one at ease, as he was a friendly and open priest who made millions of friends, and subsequently admirers, during his time as cardinal. (Courtesy SBHS.)

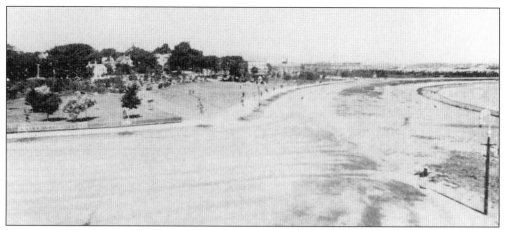

Marine Park has not changed much since the turn of the century. A cement wall divides the sidewalk from the beach today, but otherwise it is much the same.

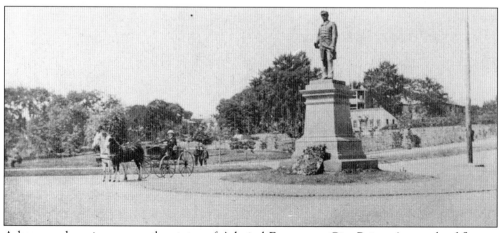

A horse and carriage passes the statue of Admiral Farragut at City Point. A wreath of flowers and laurel lies at the base of the statue during this Memorial Day in 1899.

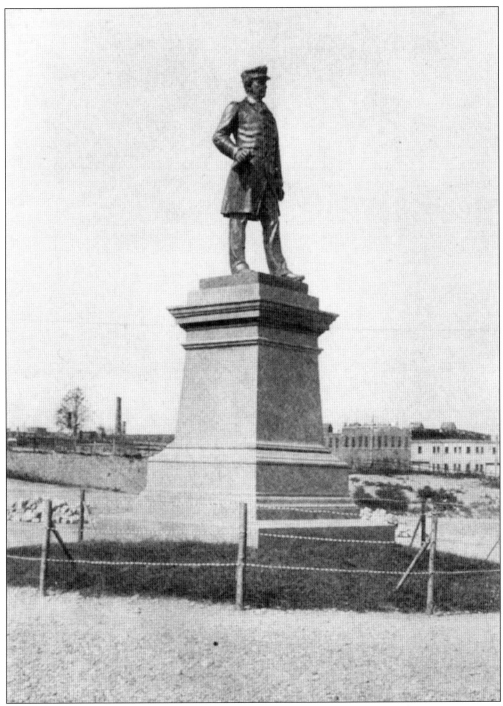

Admiral Farragut's statue was sculpted by Kitson and placed in Marine Park at City Point to honor this great admiral of the United States Navy. Born in Tennessee, David Farragut (1801–1870) began his naval career at the age of twelve and was to cap his career as the hero of Port Hudson, Mobile Bay, and New Orleans during the Civil War. After his death, this statue was erected to his memory and a school was named for him in Boston.

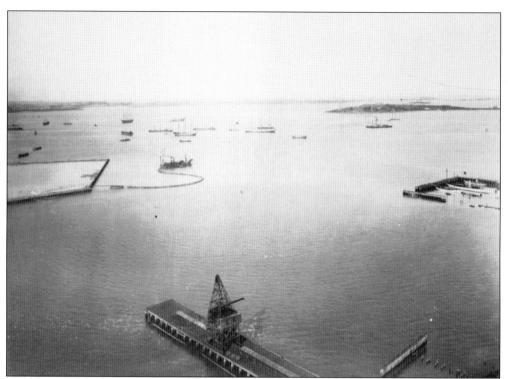

In this photograph of the South Boston waterfront, prior to World War I, can be seen: the Boston elevated coal dock; Lawley's Boat Basin (on the right); and a dredge (on the left), pumping fill for what would later become the Army base. (Courtesy SBHS.)

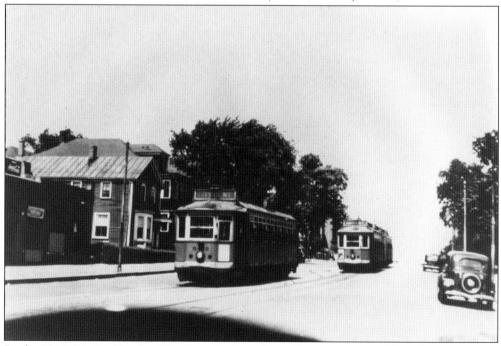

By the 1940s Marine Road at City Point had regular trolley service to and from Boston.

Eleven
Castle Island

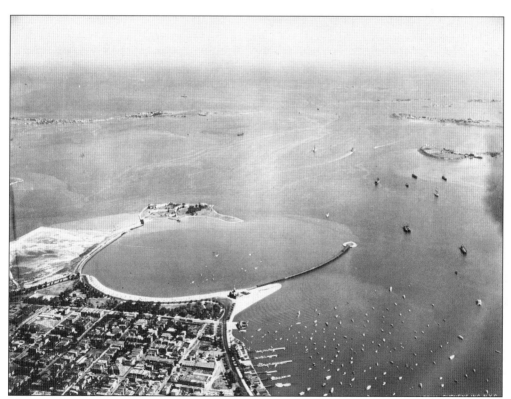

This aerial view of City Point and Castle Island, *c.* 1930, shows the area fairly well built up with the Head House (on the right) and the pier projecting into the harbor. On the left is the open land near East First Street that would later be developed as the Conley Marine Terminal. Castle Island, an irregularly-shaped island, would later be joined to the mainland when a road was built in 1932.

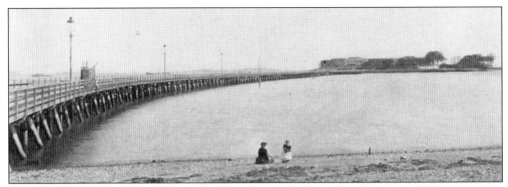

The causeway to Castle Island extended from Marine Park on piers that were driven to support the wooden planking. Here two women sit on the beach and look toward Castle Island in 1895.

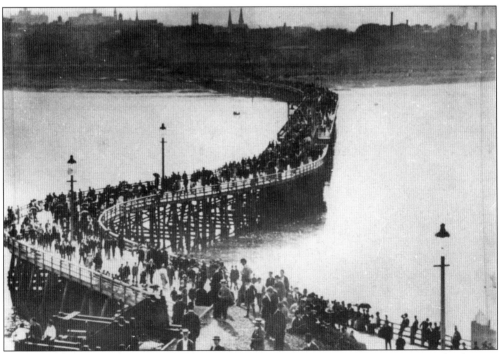

The opening of the wooden bridge connecting Marine Park and Castle Island took place in 1918. Thousands of visitors and residents of South Boston swarmed along the bridge, enjoying the views along the way. In the background can be seen the skyline of South Boston, with the spires of numerous churches and the smokestacks of factories evident.

The granite walls that protected Castle Island surrounded the island. A mine exploded here in 1898 during the Spanish-American War. On the right, makeshift wooden rafts that were used to transport mines from the harbor to the island can be seen. (Courtesy SBHS.)

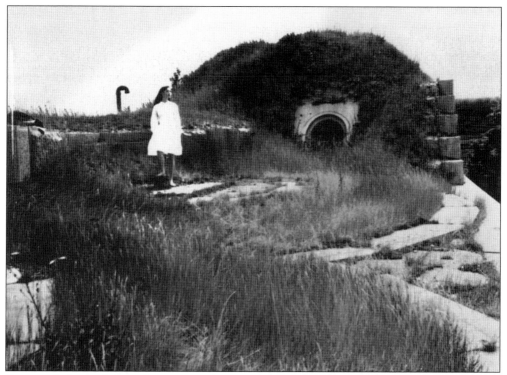

A young lady stands outside a gun emplacement and magazine on Castle Island. The strategic location of Castle Island made it a spot that required defending as early as the seventeenth century, but these defenses date from 1898, and were overgrown when photographed in the 1950s. (Courtesy SBHS.)

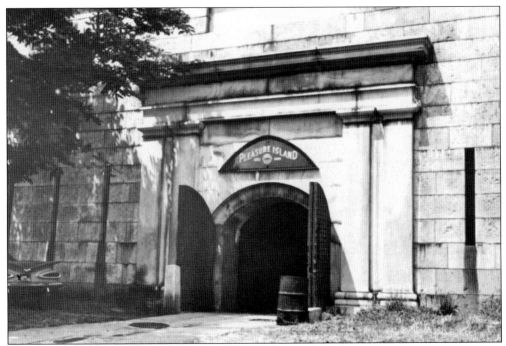

Castle Island was known as "Pleasure Island" due to its panoramic views, lusty salt air, and green lawns that made for great family picnics. With a walkway that surrounded the fort, people could exercise while they greeted friends and neighbors. The massive entrances to Fort Independence, as the "castle" is known, has a sign stating "Pleasure Island." (Courtesy SBHS.)

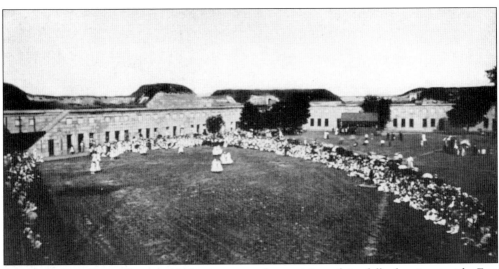

During Independence Day in 1912, many people participated in folk dancing inside Fort Independence on Castle Island. The massive granite walls of the fort encircle the audience, who are observing the dancers.

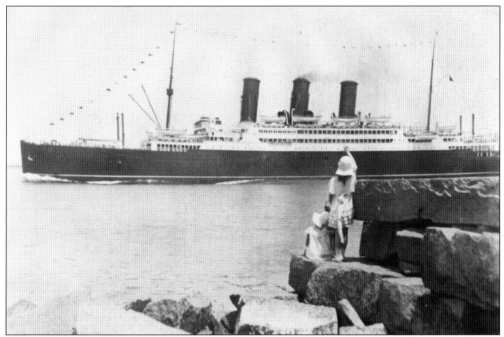

Jean and Mary Benoit wave to an ocean liner that is arriving in Boston. The Misses Benoit, in attractive sun dresses, are on enormous pieces of granite that acted as barriers for the ocean waves. Ocean liners docked at the Commonwealth Dock Head House off Northern Avenue until the 1950s, when few, if any, liners came to Boston. (Courtesy SBHS.)

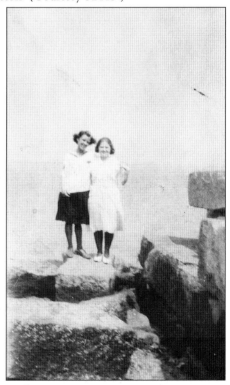

Two chums pose on the granite rocks on the edge of Castle Island in the 1920s. (Courtesy SBHS.)

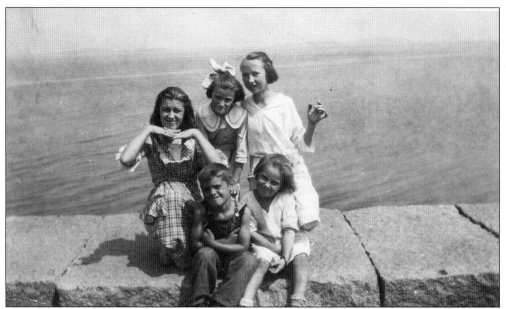

Five friends pose for a photograph on the granite wall at Castle Island in the 1920s. The outer islands of Boston Harbor can be seen in the background. (Courtesy SBHS.)

Captain Hamilton, in the dark suit, and his crew manned the Dorchester Bay Life Saving Station in Boston Harbor off City Point.

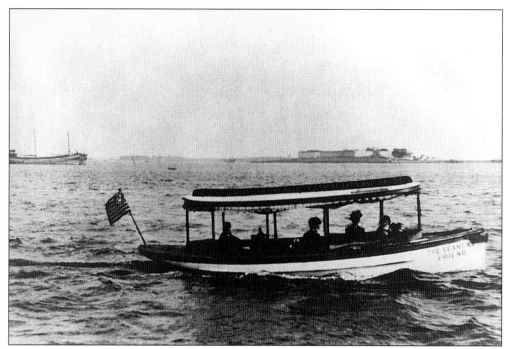

The *Seamen's Friend* was a launch used by the Life Saving Station. Here, in 1900, it passes Castle Island with passengers who obviously don't require saving, unless it was from the summer heat! Such pleasures as boating off City Point are still available today.

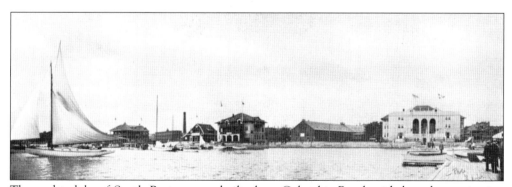

The yacht clubs of South Boston were built along Columbia Road, with launches projecting into the harbor. A group of men stand on a floating launch on the right while a sloop sails toward the harbor on the left.

Acknowledgments

This book is an outgrowth of an illustrated lecture on the history and development of South Boston, presented in 1992 for the Marjorie Gibbons Memorial Lecture at the South Boston branch of the Boston Public Library.

I would like to thank the following for their continued support and interest in this book: Daniel Ahlin; Anthony Bognanno; Frank Bognanno; John Bognanno; Helen and Paul Buchanan; Edward W. Gordon of the Gibson House Museum; James Z. Kyprianos; Gerard Logan; Dan and Betty Marotta of Sports Film Lab; Judith McGillicuddy; Jonathan T. Melick; Dr. William J. Reid, president of the South Boston Historical Society; Dennis Ryan; Anthony and Mary Mitchell Sammarco; Rosemary Sammarco; Sylvia Sandeen; Robert Bayard Severy; Anne and George Thompson; William Varrell and the staff of the South Boston branch of the Boston Public Library: Helen Maniadis (branch librarian), Paula Flemming, Irene Padden, Elaine Sullivan, and Arbutus Bradeen; and the staff of the South Boston branch of the Bank of Boston: Jeanette Ashe (branch manager), Joan Gannon, Tara Johnston, Paula Melchin, Debra Paull, Judy Peacott, and Colleen Reilly.